A–Z
OF
CONWY

PLACES - PEOPLE - HISTORY

John Barden Davies

Best wishes

John 10/03/20

AMBERLEY

Acknowledgements

Rhodri Clark (editor of History Points), Conwy Chamber of Trade, Conwy Town Council, G. H. Edwards Newsagents, Ken Hughes, Llew Groom, management and staff of Chez Illy Café, management and staff of Conwy Mussel Centre, Robin Hughes, the crew of RNLI Conwy Lifeboat, Trevor Jones, Jean Morgan-Roberts, Clive Myers, Betty Pattinson, Phyllis Pritchard, Denise Robinson, Toby and Joanne Tunstall, Jan Tyley, the vicar and churchwardens of St Mary's Church, Paul and Vivinne Wakely, and the Welsh ladies at the Smallest House.

All images are the copyright of the author except for:
pp. 8 (right), 10, 15 (top), 22, 34, 46 (top), 65 (top), 74, 79 (left), 85 (top): author's collection.
p. 13 (bottom) and Map on p. 4: Jean Morgan-Roberts, with permission.
p. 37: Ken Hughes, with permission.
p. 40 (top and bottom): Conwy lifeboat crew with permission.
p. 52 (bottom): Vicar and Churchwardens of St Mary's Church, with permission.
p. 54 (bottom): Trevor Jones, with permission.
p. 61: Betty Pattinson, with permission.
p. 90: The Smallest House Ltd, with permission.

First published 2017

Amberley Publishing
The Hill, Stroud, Gloucestershire, GL5 4EP
www.amberley-books.com

Copyright © John Barden Davies, 2017

The right of John Barden Davies to be identified as the Author of this work has been asserted in accordance with the Copyrights, Designs and Patents Act 1988.

ISBN 978 1 4456 6439 2 (print)
ISBN 978 1 4456 6440 8 (ebook)

British Library Cataloguing in Publication Data. A catalogue record for this book is available from the British Library.

Origination by Amberley Publishing.
Printed in Great Britain.

Contents

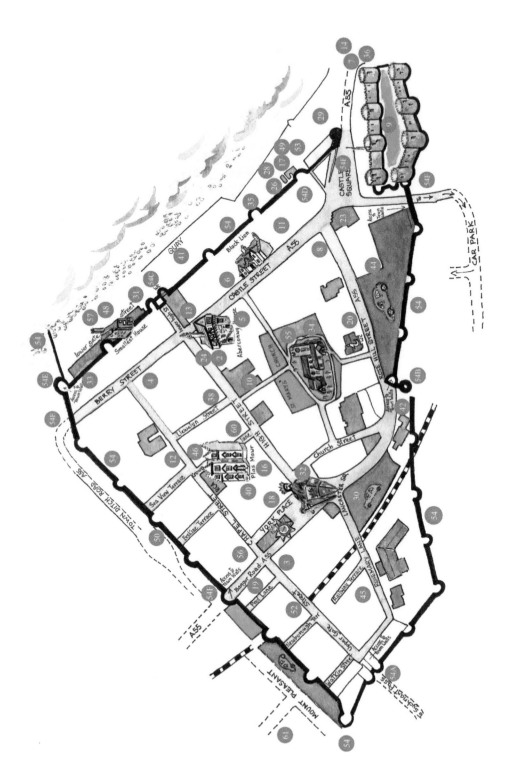

Key

The numbers on the map indicate the location of various features described in the book, such as buildings and streets. The numbers refer to the titles in the featured descriptions in the book, but please note that not every titled feature has a representation on the map as some descriptions are not of locations.

2. Aberconwy House
3. Albion
4. Berry Street
5. Black Horse Inn
6. Black Lion Inn
7. Bridges
8. Bridge Inn
9. Castle
10. Castle Inn
11. Castle Street
12. Chapel Street
13. Civic Hall
14. The Cob
16. Crown House
17. Custom House
18. Dunphy's Corner
19. Edwardian Butcher Shop
20. Erskine Hotel
23. Guildhall
24. High Street
26. Inshore Lifeboat Station
28. Keith 'Fish'
30. Lancaster Square
31. Liverpool Arms
32. Llywelyn ap Iorwerth
33. Lower Gate Street
34. St Mary's Church

35. Mussel Centre
36. 'New' Bridge
38. Palace Cinema
40. Plas Mawr
41. Quay
42. Railway Station
44. Rose Hill Street
45. Rosemary Lane
46. Royal Cambrian Academy of Art
48. Smallest House
49. Tower Coffee House
50. Town Ditch
52. Upper Gate Street
53. Vardre Hall
54. Walls
54a. Porth Uchaf
54b. Porth-y-Felin
54c. Porth Isaf
54d. Porth Fach
54e. Porth yr Aden
54f. Nineteenth and Twentieth Century Gates
55. We are Seven
56. Archbishop John Williams
57. Margaret Williams
60. Ye Olde Mail Coach Inn
61. Zoologists.

Introduction

It is no wonder that Conwy attracts large numbers of visitors from all over the world, as the town is unique. Visitors to Conwy find something refreshingly different in an age when so many larger towns are losing their individual character. The castle, the walls, the bridges and the many ancient buildings all draw people in to visit the town.

It is often asked how Conwy has managed to preserve its ancient heritage when so many other towns have lost theirs. It is certainly not by accident. Most of the tourist attractions of the town could have been lost if many of the road improvement schemes and other plans over past years had come about. One scheme was to take a road through the middle of the castle, leaving just a wall at each side. Another would have taken a new road along the Quay, demolishing the old cottages, the Smallest House and part of the town walls and put the fishermen out of work. Also, after the new bridge was built, there was a plan to demolish Telford's suspension bridge and in more recent years, when a new river crossing was needed, there was a plan to build a large bridge to the south of the present bridge, which would have dwarfed the castle. The town's railway station was lost for twenty-three years until it was reopened. It was the people of Conwy who objected to these schemes and have made the town the popular place it is today, retaining the many tourist attractions. As well as Conwy's historic buildings, the small privately owned shops, pubs and cafés are as much a part of the town's heritage as the historic buildings, because they also attract people to Conwy. This all makes a major contribution to the town's economy.

However, Conwy is not a museum, it is a town where people live and work and in this book I have set out to say something about the people and places, past and present, that make Conwy the town it is today. I have generally kept the features of the book within or very near to the town walls. Many of the old buildings have changed their names and their functions over time, so I have used the original names in order to tell their story from the beginning.

I have received much help from the people of the town while writing this book. They have been more than willing to share their memories with me. I dedicate this book to the people of Conwy, past and present. May those who come after them continue to ensure the town retains its attraction in a modern age, so that future generations may enjoy living and working in the town and visiting it.

A

1. Aberconwy Abbey

In the latter half of the twelfth century, the site where the town of Conwy now stands was remote, particularly because of the difficulty of crossing the river. This was ideal territory for the Cistercians to build an abbey as they liked to build in isolated locations where they could be free to worship in peace. So a Cistercian abbey was commenced in the 1170s and completed in 1186. In later years, the abbey was much favoured by Llywelyn ap Iorweth (Llywelyn the Great), Prince of Wales, who endowed it, gave it much land and exempted it from paying many taxes and dues. It was also favoured by other Welsh princes who followed Llywelyn the Great.

Despite its peaceful location, the abbey was not immune from attack. Deganwy Castle on the opposite bank of the river was destroyed twice by the Welsh princes to prevent it falling into enemy hands, but by 1245 Henry III repaired it and for a while remained there with his troops. During a particularly harsh winter, the garrison at Deganwy was running out of food and waiting desperately for a ship to bring supplies from Dublin. The ship, which was carrying a valuable cargo of wine and other provisions, eventually arrived in very stormy weather and the crew, possibly unfamiliar with the tricky navigation needed to negotiate the sandbanks, failed to land at Deganwy and instead the ship was blown ashore onto the other side of the river at the Morfa. At that time the abbey's charter allowed them to salvage any ship that was wrecked on the western bank, so they wasted no time in claiming their rights of a good supply of food and wine, and after this the Welsh troops set fire to the ship.

When Henry's troops realised what was happening, they crossed the river in pursuit, but they were too late as the Welsh had already retreated to the mountains and forests with the provisions from the ship. Henry's troops continued to pursue them and a battle followed, with casualties on both sides. In revenge, Henry's troops set fire to the abbey and destroyed many valuable books and ancient records. The abbey, in fact, housed a depository of Welsh national records and literature, much of which dated over many centuries. Two years later, it seems that the king regretted his action in damaging this sacred place, and he issued a decree guaranteeing protection for the abbey and its monks. The abbey was repaired but when Edward I invaded in 1283, with his plans to build a castle and a new walled town, he had the monks moved to

Maenan in the Conwy Valley. As monks disliked towns, they were probably pleased to be moved to a rural location where they could worship in peace. Conwy Parish Church now stands on the site of the Abbey Church and possibly a few stones that make up the church are originally from the abbey. The 'new' abbey built at Maenan was dissolved by Henry VIII in 1539 and virtually nothing of it remains except for a few stones, but the Maenan Abbey Hotel at that site serves as a memory.

2. Aberconwy House

Aberconwy House is the last surviving house in Conwy from the medieval period. It is distinctly English in style, which reflects the earliest era in Conwy's long history when the then new town was populated by wealthy English families, many of whom were merchants. There would have been other similar houses at the time that served as both residences and warehouses, most of them were conveniently near to the Quay.

The oldest part of the house is the ground floor, thought to date from the fourteenth century. The upper floor was added later and, according to analysis of the timbers, it dates from 1420. It was owned by a succession of English merchants but by the nineteenth century had become a temperance hotel. Such places came into being as an alternative to public houses to enable people to socialise in an alcohol-free environment. The building was bought by the National Trust in 1934, who have been its owners ever since. There is an interesting museum inside the house where different rooms have been furnished in contemporary fittings from many periods in its history, including Jacobean, Georgian and Victorian. There is also a shop.

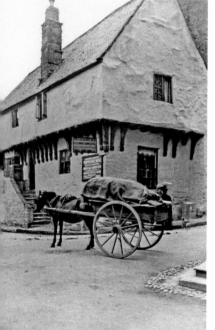

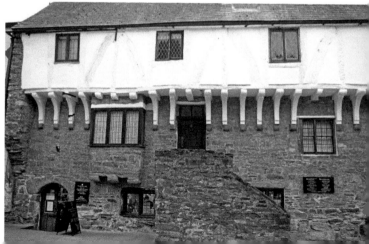

Left: Aberconwy House, when horse-drawn transport was the norm.

Below: Aberconwy House as it is today.

stle St. Conwy.

Over the years, many stories have emerged claiming the house to be haunted. Such claims include creaking floorboards, doors opening of their own accord, apparitions such as a man in Victorian clothing, a woman in Jacobean clothing and also the sound of footsteps. Whether such stories are true is a matter of opinion, but whatever, this old house is well worth a visit and is full of interest.

3. Albion

The Albion is one of Conwy's most popular pubs. It was built in the 1920s on the site of two former pubs at the corner of Upper Gate Street and Bangor Road. The pub remained popular for many decades, retaining many features that other pubs had abandoned. It was closed in 2010, but was reopened in 2012 by a local brewery, who restored much of the interior to its authentic 1920s style with three rooms. A very interesting feature of the Albion is the traditional furnishing at the main bar with a clock incorporated into it. It is well worth visiting the pub just to see that, as well as to sample the variety of ales available. It remains popular to this day, particularly with local people as a traditional real ale pub. There is a story attached to one of the earlier pubs on the site that in 1919, R. O. Williams, the licensee, was fined £15 for charging more than the official price for two bottles of ale. The Campaign for Real Ale awarded the Albion with the honour of being Pub of the Year in 2016.

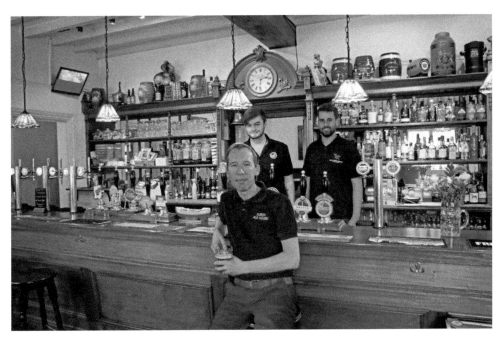

The Albion landlord, Stuart (seated), with Kieran (left) and Graham (right).

4. Berry Street

People trying to guess the origin of the name 'Berry Street' might think of it as having some connection with an orchard or fruit and vegetable garden. It is probable that its true origins are lost in the mists of time. However, there are many stories as to how the street got its name. The best known of these stories says that the name is not actually 'Berry Street' but 'Bury Street' and has its origins at the time of the Great Plague in the seventeenth century. The plague mostly affected large cities, particularly London, where people lived in close proximity, but small towns and rural areas were not immune. The plague was carried by rats and in those days most ships had a few rats on board, so it is likely that the plague spread to Conwy by the many ships that visited the town in those days. The story goes that the town began to run out of burial space, so a mass grave was dug in this part of the town and that it was given the name 'Bury Street' and in later years changed to 'Berry Street'.

Maybe the story is true or maybe it is not, but it is certain that in those days, indeed up until the nineteenth century, Berry Street was a little-used cul-de-sac and the wall at that point was not breached until the early twentieth century. At the end of Berry Street near the arch, itinerant preachers were permitted to preach in the open air,

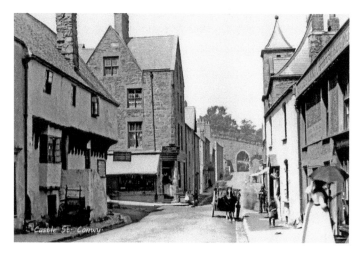

Berry Street leading to the arch in the early twentieth century.

Berry Street as it appears today.

Berry Street from outside the arch, looking beyond into Castle Street.

earning the area the nickname 'Bedlam Barracks'. At one time there was an inn near the arch that was called the Soldiers' Rest. Another feature of this area in the past was a dog pound where stray dogs were kept. At the end of Berry Street next to the arch, there is a building that was once a smithy. It has now, for many years, been a centre for elderly people supported by volunteers. The centre is known as Clwb yr Efail, ('*efail*' is the Welsh word for 'smithy').

5. Black Horse Inn

Conwy had many inns in the nineteenth century but many of them have long since been put to other uses. An example of this is the former Black Horse inn on Castle Street. Its most famous licensee was the Welsh bard Thomas Roberts (Myrddin) who was landlord from 1834 to 1856. By the beginning of the twentieth century, the building had ceased to be an inn and was converted into two shops. It later became the Emu restaurant and then the Victoria Tea Rooms. In 1932, the building was taken over by the Veale family as

Former Black Horse Inn in Castle Street, now Pobty Conwy Bakery.

a bakery, which remained in the Veale family until 1998. It is still referred to as Veale's by many old Conwy people. It was taken over by the Roberts family in 1998 and trades as Popty Conwy Bakery. It remains very popular with locals and tourists alike for its bread and pies baked on the premises and its delicious homemade cakes and vanilla slices and also homemade bara brith to a traditional Welsh family recipe.

6. Black Lion Inn (and Jean Morgan-Roberts)

If you look for a Black Lion inn sign, you will not find it, but the building in the middle of Castle Street, which once was the Black Lion Inn, is one of the oldest buildings in the town and has had a variety of uses. The date above the door is 1589, together with the initials 'JB', which refer to John Brickdall, a one-time vicar of Conwy. It seems that he bought the house in 1589, but whether he used it as an official vicarage or a private dwelling is not known, but the name Brickdall House was used until long after Brickdall's death. As stagecoaches began to come into Conwy in the eighteenth century, the building was converted to a coaching inn and took on the name Black Lion. At one time, a pig market was held every Monday behind the building. Recent examination of the roof timbers has established that they date from the 1440s. It is possible that in 1589 Brickdall bought the house and rebuilt or extended it. The Brickdalls were a well-known Conwy family for centuries and one of John Brickdall's ancestors was a governor of the castle. As well as having an entrance from the street, the Black Lion has its own steps onto the town walls and its own well. Also, there is a story about a secret escape route through a tunnel under the walls leading to the Quay. This may well be true as it may have been a useful escape for many during the Civil War, when the town's gates were well guarded. There are also stories that the building is haunted.

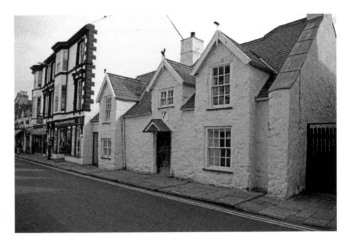

Former Black Lion Inn in Castle Street, now in private ownership.

Jean Morgan-Roberts

The building continued as an inn until the mid-1930s when it was bought as a private residence by William Henry Morgan, father of famous Conwy artist Jean Morgan-Roberts. Jean was born in the Black Lion so she is a Conwy 'Jackdaw' and it was there that she was brought up. As her father encouraged her to appreciate the natural environment around her, Jean soon taught herself to paint and quickly recognised the many different bird species she saw around Conwy Quay and Harbour and, while still a child, she began to paint pictures of these creatures as she came to appreciate colour. In fact, her painting style with a colourful and cheerful outlook soon made her a favourite among many art collectors. Jean sells her paintings in all parts of

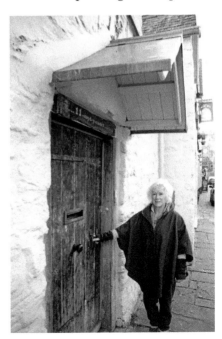

Conwy artist Jean Morgan-Roberts, who was born in the Black Lion.

the world from Australia to the Far East and North America. Her work is also for sale at local galleries. Jean, who speaks three languages, is well-travelled and the beautiful places she has visited have influenced her paintings. She particularly likes South America. Although Jean no longer lives at the Black Lion, the building is still a privately owned residence. An interesting feature is the carved jackdaws on the roof, which are indicative of the name given to people born within the town walls. Jean no longer keeps her own shop, but her work can be seen and bought locally at Conwy Visitor Centre and the Craft Centre at Bodnant Garden in the Conwy Valley.

7. Bridges

On Christmas Day 1806, the Conwy ferry sank, resulting in the loss of eleven lives. The ferry was also carrying mail bound for Ireland. From this time onwards there was public pressure to build a bridge as the ferry was unreliable and dangerous. The engineer Thomas Telford was called in to build a bridge that would complete the improvements he had made to the Chester to Bangor Road, the precursor of today's A55. Telford also improved the road from London to Bangor and Holyhead via Shrewsbury and Betws-y-Coed, which was to become the A5. In those days, overland travel was by stagecoach and the coaches carried mail as well as passengers. Telford's bridge at Conwy, completed in 1826, made access to Conwy much easier and tourists began to visit the town.

The castle had by this time become a ruin and was of particular interest to artists. It is notable how Telford designed this suspension bridge to look attractive and to blend with the towers of the castle. The chains on one side of the bridge were anchored into the castle and the other side of the bridge was connected to a small island known as 'Yr Ynys'. From there, it was linked to the other side of the river by a causeway that Telford also built (*see* 14. Cob). Later, a pedestrian walkway was built but it was demolished in 1958. Telford also built two toll houses, one at each end, and these remained in use until the bridge closed in 1958, although the one at the eastern end still stands.

Twenty-two years after Telford built his bridge, the railway came to Conwy and Robert Stevenson, son of George Stevenson, who was called the father of railways, built a tubular bridge across the river to carry the railway. This was achieved by erecting the tubes on the bank of the river, then floating them out and lifting them into position. This bridge remains in use today and is now the only one of its type. After the new road bridge was built in 1958, there were plans to demolish the suspension bridge but, after public protest, it was taken over, together with the tollhouse, by the National Trust. The bridge was then closed for a while for restoration, costing £2 million, and was reopened in 1995. The surviving toll house is open to the public, so it is possible for people to go inside and to walk across the bridge. There used to be another bridge between the suspension bridge and the railway bridge, but it was

hardly noticed by people, and it became a popular local quiz question, which asked: 'How many bridges cross the river at Conwy?' Most people got the answer wrong because they didn't know about it. This bridge, also a suspension bridge but a smaller one, was built by Farrington in 1894 to carry water pipes to Colwyn Bay from Llyn Cowlyd, a reservoir high in the mountains. When the new bridge was built in 1958, this bridge was demolished and the water pipes rebuilt underneath the new bridge, where they remain today.

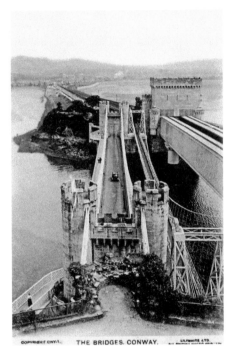

Telford's suspension bridge, water pipes' suspension bridge, railway bridge (left to right).

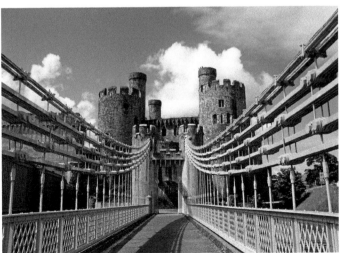

The suspension bridge, designed to blend with the architecture of the castle.

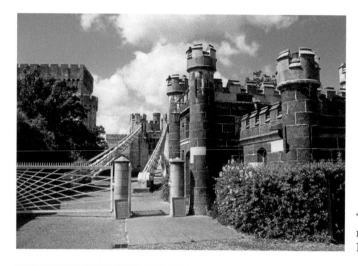

Telford's bridge toll house, now preserved by the National Trust.

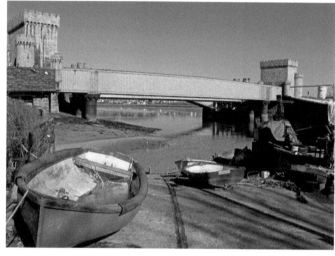

Stevenson's railway tubular bridge. Gyffin stream enters from the left.

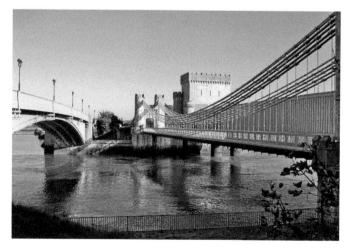

Three bridges (left to right): 'new bridge', suspension bridge, tubular bridge.

8. Bridge Inn

The first thing today's visitors to Conwy do when they arrive in the town is to look for refreshments. Travellers in the past were no different, and for those who entered, the town over Telford's suspension bridge, the first place of refreshment they would see was the Bridge Inn, but this mid-nineteenth-century pub was originally called the Castle View Hotel. By the end of the nineteenth century it had become a temperance hotel and was renamed Bridge Hotel, a name it retains to this day. One of its most famous guests in the late nineteenth century was Elizabeth Driver, an American soprano. She performed in St Mary's Church and soon became popular with the Welsh people. A group of bards, members of the Geirionydd Gorsedd, initiated her into their bardic group. She took the bardic name Llinos Maldwyn ('*llinos*' is the Welsh word for 'nightingale'). This was a great honour indeed as Llyn Geirionydd, an attractive lake above Trefriw in the Conwy Valley, was the origin of some of the most famous Welsh bards, including Taliesin, a sixth-century poet whose work is believed to be the oldest surviving Welsh poetry, and also the nineteenth-century poet Ieaun Glan Geirionydd, who composed many hymns. Following this, Elizabeth was a soloist with the Liverpool Philharmonic Orchestra. The Bridge Inn remains a popular hostelry today and is now run by a group of North Wales breweries serving locally brewed beer. The pub has a particularly attractive inn sign depicting the bridge and there is an old RAC road sign on the wall, which has been there for many years.

The Bridge Inn. Note the attractive inn sign and old road sign.

9. Castle

The castle dominates the town of Conwy, but its artistic design can sometimes make people forget that it was built as a grim military fortress. Edward I began his invasion of Wales in 1277, by which time he had built castles at Flint and Rhuddlan. The wars continued and the Welsh princes, Llywelyn ap Gruffudd and his brother Dafydd, grandsons of Llywelyn the Great, fought to try to repel the invasion. Dafydd attacked Hawarden Castle in 1282, which infuriated Edward, who began the next stage of the English/Welsh wars. Llywelyn went to fight for his cause in other parts of Wales and left Dafydd to look after Gwynedd. Llywelyn was killed by Edward's troops near Builth in Powys in 1282. He became known in Welsh as 'Llywelyn, ein Llyw Olaf' (Llywelyn our Last Leader). This encouraged Edward to cross the Conwy River the following year and put into action his plans to build a castle and a new walled town, which he populated with wealthy English gentry, the indigenous Welsh people not being allowed to live or even to trade in the new town. Conwy Castle needed no moat nor concentric walls as its location on a high rock was defence in itself. It consists of two wards and eight towers. There were two entrances to the castle, one on the east side, used frequently by people who crossed the river at this point, who then walked along a path and then passed through a gate and climbed steps into the castle. The gate was demolished when Telford built the suspension bridge but the remains of the steps can still be seen.

However, Edward did not have everything his own way and, in 1294, Madog, a relative of Llywelyn the Great, planned a resistance against English rule in all parts of Wales. He captured Denbigh Castle and attacked the then incomplete Caernarfon Castle. Edward, who was taken by surprise, hurriedly escaped from Caernarfon and tried to muster his troops but he was stopped at Penmaenmawr and forced to retreat to Conwy Castle, where he was trapped for fourteen days while Madog's troops set fire to the town. Provisions were running low but Edward was eventually rescued by troops who crossed from the eastern bank. The castle entered a quiet period in the early fourteenth century. A report of 1321 mentioned rotting roof timbers and the castle was reroofed in 1346.

Others who featured in the castle's story were Richard II and Owain Glyndwr, and other events were the Wars of the Roses and the English Civil War (see separate sections

of this book). After the civil war, the military days of Conwy Castle were really over and it once more returned to private ownership. Parliament ordered it to be partly destroyed to make it unusable for military purposes. Later, the lead was stripped and the castle became a ruin. By the late eighteenth century, it became of more interest to artists than to soldiers and following completion of the road bridge in 1826 and the railway bridge in 1848, it became a tourist attraction and its ownership passed to civil authorities. There was, at this time, concern about one of the south towers of the castle, which was already damaged, because the passage of trains could cause more damage, but the railway company repaired the tower at their own expense. In 1953, the castle passed to the government body, the Ministry of Works, and by the twenty-first century to Cadw, which is the department of the Welsh government that cares for historic buildings. The castle, classed as a world heritage site, is visited by thousands of people every year. It takes only a little knowledge of Conwy's long history and some imagination to think that if the old stones of the castle could talk, they would have many an interesting story to tell.

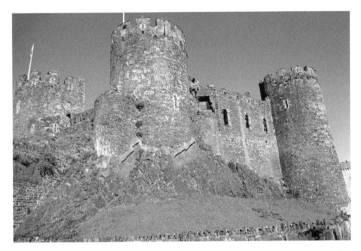

Conwy Castle's strength is its position on a high rock, as is evident here.

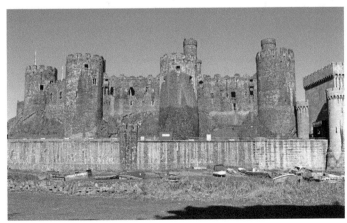

The castle from the south and railway bridge entrance on the right.

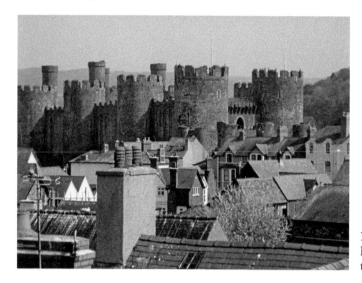

Note the impressive height of the castle over the other buildings.

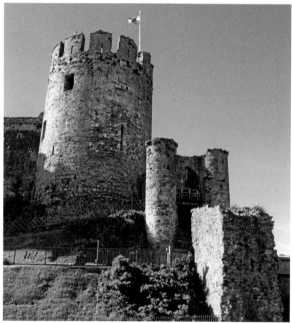

The site of the old drawbridge. Note the Welsh flag flying from the tower.

10. Castle Hotel (and King's Head)

The Castle Hotel in High Street occupies a site where there were previously two hotels, the King's Head and the Castle. The King's Head dates from the sixteenth century and some parts of the wall at the back are thought to be twelfth century, from Aberconwy Abbey. The two hotels continued in business until the late nineteenth century. It is thought that local workmen drank at the King's Head while wealthy

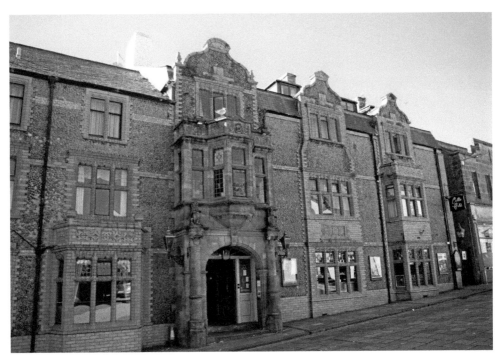

The Castle Hotel. This 1880s building replaced a previous one.

visitors patronised the Castle Hotel. There was another inn next door, known as the Harp. From the eighteenth century onwards, and particularly after the bridges were built, in the nineteenth century many visitors came to Conwy, and the Castle Hotel became much busier.

Among the famous people of the time who stayed there were Samuel Johnson, writer and literary critic, and also the poet William Wordsworth and author Charlotte Brontë. Another famous guest at the hotel was the railway engineer Robert Stevenson, who designed the tubular bridge. He and his father George were present at a special celebration dinner in 1848 in honour of the arrival of the railway. The two hotels underwent many stages of rebuilding and, although they were effectively merged in about 1830, they continued as separate businesses until 1884 when a Miss Dutton, owner of the Castle Hotel, purchased the King's Head and it became part of the Castle Hotel. The following year, a new frontage was built, which was designed by the architects Douglas and Fordham of Chester. This well-known Victorian firm of architects designed many large buildings in Cheshire and North Wales. The churches of their design that are close to Conwy are at Deganwy, Colwyn Bay, Old Colwyn and Bryn-y-Maen. This frontage remains in place today. The Castle Hotel remains a popular and quality establishment in the centre of the town and welcomes visitors from all parts of the world. The room on the ground floor to the left of the car park entrance has been used for many purposes and it is now occupied by Conwy Art and Craft.

11. Castle Street

Castle Street is one of the main streets in Conwy and, as its name suggests, it leads to the castle. However, this is somewhat unusual as in most castle towns, it is usually the high street that leads to the castle, so this is something else that makes Conwy special. It carries the traffic flowing through the town in a west–east direction. It contains a number of interesting shops, cafés, restaurants and pubs, including some very old buildings. At one time, Castle Street contained many more pubs and inns than it does now. There was once the Eagles Inn. The Eagles building is still there and is now occupied by a shop.

Today, there are two pubs in Castle Street, the Blue Bell and the George & Dragon. The origin of the name 'Blue Bell' is uncertain but there are some claims of a connection with a bell that was rung to summon the ferry. The Blue Bell housed Conwy's first telephone exchange in 1896 and initially there were just twelve phone lines in the town. In the eighteenth century, civil courts were held at the Blue Bell to decide on cases of agriculture and land transfer. The George & Dragon, next door to the Blue Bell, was once thought to be two buildings with a passage between them. An interesting story about the George & Dragon from the early twentieth century is that the landlord had a pet monkey, which became friends with a kitten and the two animals remained friends even after the kitten grew up. It was not considered unusual for a pub landlord to have a pet monkey, but no doubt it was of interest to the customers.

One of the most interesting buildings in Castle Street is Ye Olde College. There are many stories and opinions as to its origin. One old story suggests that Llywelyn ap Iorwerth erected a building here, and another that Edward I built a college here, but both stories are uncertain. Parts of the present building have been shown to date from the early sixteenth century, and may well have been built by the Stanleys, an influential family in those days who helped Henry VII to secure the throne. The Stanleys may well have settled in Conwy at that time, as it was a popular place to live for wealthy people in Tudor times. By the twentieth century, the building was

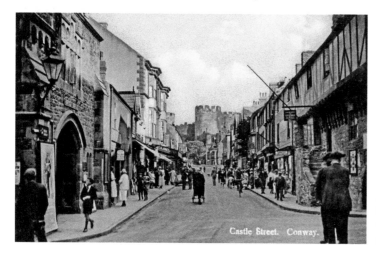

Castle Street. Conway.

A busy Castle Street in the twenties or thirties without any motor traffic.

The Old College (now Betfred) and Time (which for many years was Clemence restaurant).

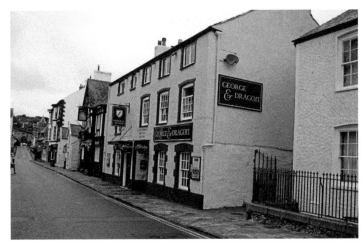

The George & Dragon and Blue Bell pubs in Castle Street.

occupied by a number of shops. Today it is a bookmaker's shop. A building in Castle Street named Regent House was once a high-quality ladies' and gents' clothes shop. The shop has long since gone and today is two shops, one occupied by a clothes shop and the other by a greengrocer's shop.

12. Chapel Street

Chapel Street, which runs parallel to High Street, is quieter and less well known than the other main streets of the town. It is so named because of the chapels in the street that were built in the late nineteenth and early twentieth century, which was a time of rapid chapel building in Wales. There were once three Welsh chapels in the street, which included Tabernacl, a Wesleyan chapel that closed in 2011 and is now privately owned, and Seion, an independent chapel that closed in the early 1990s and is now occupied by

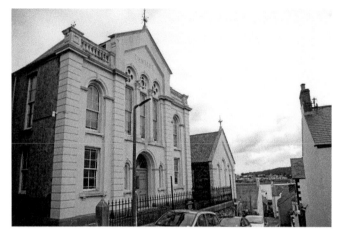

The impressive Carmel Welsh Presbyterian Chapel in Chapel Street.

The Chapel Street entrance to the garden of Plas Mawr.

the Royal Cambrian Academy of Art. The only remaining chapel in the street that is an active place of worship is Carmel Presbyterian Chapel, which is an impressive building. There is a disused Baptist chapel in nearby Church Street. Otherwise, Chapel Street is a residential area that contains small attractive cottages. At the top of Chapel Street are the remains (no more than a wall) of the residence of Archbishop John Williams and next to it is the popular Watson's restaurant serving good quality lunches and dinners. Before the chapels were built, Chapel Street was known as Union Street, named after the Union Tavern that once existed at that location.

13. Civic Hall

This building, at the corner of Castle Street and Lower High Street, has had many uses over the years and was once used as a market hall and also as a town hall. In the Second World War, it was used as a canteen. In the 1960s, it became known as the Civic Hall, and was restored and included a library but, unfortunately, just weeks

A side view of the Civic Hall
from Lower High Street.

after the restoration, the building suffered a disastrous fire, which was the biggest
fire that had occurred in Conwy in recent times. Part of the old building was saved
but a new section was added, which incorporated a theatre. The theatre was initially
a successful project, but by the twenty-first century, it was being used much less
frequently and closed in 2014. The building continues to house the public library, but
at the time of writing, there are plans to relocate the library and to sell the Civic Hall.
The proposal has met with opposition from many Conwy people who feel the building
should be retained by the community as a civic amenity. So this old building has not
only a sad past, but also faces an uncertain future.

14. The Cob

To those who cross the river by any of the three bridges at Conwy, it appears that
the river is very narrow at this point, but this has not always been so. In fact, before
the suspension bridge was built, the river at this location was quite wide. Telford's
suspension bridge was built with the chains on one side attached to the castle and, at the
other side, there was a small island known as Yr Ynys. Telford then built an embankment
between Yr Ynys and the opposite bank of the river at what is now Llandudno Junction,
which was to carry the traffic across the river to the bridge. This is known as the Cob.

This made a difference to the flow of the river as it became concentrated under the
bridge, which resulted in strong tidal currents. When Stevenson's railway bridge was
built in 1848, the Cob was widened to allow the railway tracks to cross, and later a
railway siding was built at this point, which in the mid-twentieth century was used to
store railway carriages when they were not needed in the winter. In the late nineteenth
century, a small park area was built on Yr Ynys, which remained in place until the late
1950s when it was demolished to make way for the new bridge. On special occasions,
Yr Ynys would be illuminated with fireworks lit from nearby barges in the river.
Originally, there was a steep slope to the river from the north side of the Cob, but in the

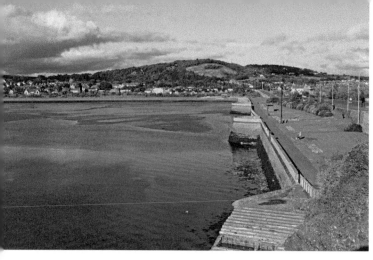

The Cob, looking east
towards Llandudno Junction.

The evening sunlight catches
a train crossing the Cob.

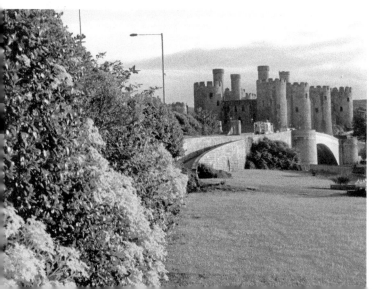

The castle from the pleasant
garden on the Cob.

1920s a walkway was built. Although some twentieth-century postcards refer to this as the 'Promenade', it is never known as this by local people who simply call it 'The Cob'.

Today, it is an attractive area with gardens, small trees and shelters that make a pleasant walk from Conwy to Deganwy and Llandudno, which is part of the Wales Coastal Footpath.

15. Harry Cross

In the days when the Conwy Honey Fair occupied stalls in Castle Street as well as in High Street, and went on late into the night, there was a stall run by a Harry Cross, who hailed from the Manchester area. He sold a large selection of kitchen, bathroom and bedroom linen together with a good variety of other textiles. His stall was very popular and many people came to the fair with the sole purpose of going to his stall, which was always in Castle Street. Harry's banter with the crowd was real entertainment in itself. Most people who knew Conwy in those days will have their memories of Harry. My own memory is when he was engaging in the usual banter while trying to sell some tea towels, but sales on these items were going very slowly, so he said to the crowd something like, 'You think I'm making a big profit on these, don't you? But let me tell you, for all the profit I'm making on them, I might as well give them away.' At that point a gentleman in the crowd shouted, 'Go on then, give one to me.' Harry immediately threw a tea towel to the gentleman concerned and addressed some expletives to him. (*Author's note: I remember this well because that gentleman was my father!*)

16. Crown House

The steep and narrow Crown Lane links High Street with Chapel Street, and at the bottom of Crown Lane is a building that was once known as the Crown Inn. The inn flourished in the second half of the nineteenth century as the town became busier, with

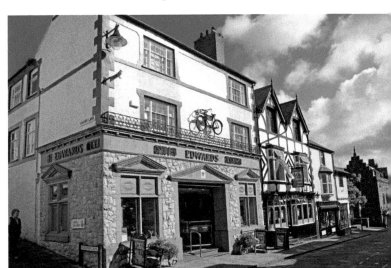

Edwards's butcher shop on High Street.

many travellers passing through. By the early twentieth century, it appears the Crown ceased to provide accommodation and as a result lost its licence in 1909, a year after landlady Jane Davies died. A heroic story associated with the inn is that in 1879, a five-year-old child fell down the well but was bravely rescued by policeman John Pritchard. The Crown's days as an inn ended in 1925 when the building became a branch of Barclays Bank, which it remained until 1995 when Conwy Valley farmer Ieuan Edwards opened a butcher's shop. Since then, Edwards's butchers has gone from strength to strength, winning many awards and drawing its customers from a wide area. A feature of the shop that is much appreciated by its customers is a notice board that gives the names of the local farms who have supplied produce to the shop. The shop is famous over a wide area for its sausages, which are popular in many local restaurants.

17. Customs House

For as long as there have been ports, there have been customs houses, to keep an eye on the passage of goods and to see that due taxes were paid on imported goods. Conwy was an important port until the late nineteenth century and the Customs House on the Quay would have been kept busy. Although the building dates from the nineteenth century, it is very likely that an older building at the same site preceded it. By the end of the nineteenth century, it had ceased to be used as a customs house as the development of ports in large cities and rapid transit of goods by the newly built railway meant commercial trade into Conwy by sea had all but ceased. The building's role as a customs house is still recalled in the small terrace of houses adjacent to it known as Custom House Terrace. For many years now, the building has been the headquarters of the Conwy harbour master and staff. Most of their work today is with the many leisure craft using the river, and the marinas at Conwy and Deganwy, and the Deganwy jetty, also come under their control.

Harbour master's office, formerly Custom House, with Custom House Terrace on the left.

D

18. Dunphy's Corner

Many older Conwy people still refer to the building at the corner of Lancaster Square and High Street as Dunphy's Corner, although before Dunphy's took over the building, it was for many years known as the corner shop. Dunphy's was a branch of a large licensed grocery company that had nearby shops in Deganwy, Llandudno, Craig-y-Don and Penmaenmawr as well as in Conwy. The company was formed in the nineteenth century. Licensed grocers were popular in the days before supermarkets and usually carried a good selection of high-quality wines. Dunphy's Corner, which had been a feature of Conwy for so many years, closed in 1972 and the business was bought by George Edwards from Shropshire, who opened it as a newsagent. George is now retired. The shop is now run by his son and carries a large range of miscellaneous items and remains popular with locals and visitors alike. Many years ago, there was a pub next door known as the Ship Inn.

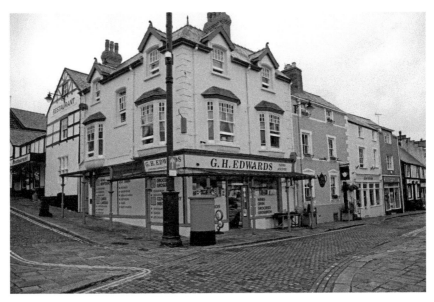

Edwards's newsagent, in High Street for many years, was known as Dunphy's Corner.

19. Edwardian Butcher's Shop

David Owens opened a butcher's shop in Bangor Road in 1896. In 1910, he built a new shop and residence next door. The family continued to trade as butchers from there until 1971. The shop has had various occupants since then but what is of particular interest is that when it was refurbished in 2012, and became a shop selling artwork and antiques, the original fittings of the butcher's shop were discovered, including the original bell, chopping boards and tiles. At the time of writing, the shop is empty. The Owens family also owned the Rhos Mill Farm at Gyffin and it was from there that they supplied their own shop and they had their own slaughterhouse. The land is now part of the Castle View Estate. This former butcher's shop should not be confused with Edwards's butcher's shop in High Street, which has no connection with it.

Former butcher's shop, notice the green tiles (outside) and white tiles (inside).

20. Erskine Hotel

The Erskine family were wealthy landowners in the area in the nineteenth century. Their connection with Conwy is that Jane Silence Williams, daughter of the Revd Hugh Williams, inherited her family's two estates, Bodlondeb at Conwy and Pwllycrochan, 4 miles to the east. The hotel has a claim to fame in that the famous author Charlotte Brontë and her husband stayed there while on their honeymoon.

In 1821, Jane married David Erskine from Scotland and, as she was the sole heiress of her family's estates, David Erskine jointly inherited them. After their marriage, they came to live in Pwllycrochan, but David (by then Sir David Erskine) died in 1841. It is believed that Jane was generous to the poor of the community. In 1865, she sold her estates in North Wales and went to live away from the area. The Pwllycrochan Estate was sold to a Manchester business syndicate, on which they built the town of Colwyn Bay, and Bodlondeb was sold to Albert Wood. There is a memorial to Jane Silence Williams in St Mary's Church, and further reminders of the family exist in Conwy to this day, in the Erskine Hotel opposite the railway station and Erskine Terrace off Chapel Street.

It is likely that the Erskine Hotel was built to serve as a convenient location for the railway station. One resident at the hotel at the end of the nineteenth century was a Mr Griffith, who was a native of Bangor. He had lived in Canada for some years and was sent to Conwy as an agent of the Canadian government to persuade people of the benefits of emigrating to Canada. As the twentieth century dawned and motor cars began to appear, many hotels closed their stables, but the Erskine retained its stables. It has been said that they were always available to tow the fire engine. Also, in the early twentieth century, horse fairs were held at the hotel. A few years ago, the hotel was renamed The Malt Loaf, but it is currently being refurbished and it is said that it will revert to its original name. There are two interesting stories associated with the Erskine, both from the late nineteenth century. One describes the absence of motor traffic at that time as a heifer walked into the hotel and went upstairs before it was removed from the premises. Another old story is the landlord was one of the first to be fined for a breach of the Sunday drinking laws.

21. Fairs

The Seed Fair and the Honey Fair are annual features of Conwy life that draw many people to the town, both locals and visitors. Fairs go back to very early days and until 1830 there were four fairs held every year, in April, September, October and November. It is said that as well as trade there was much entertainment and even fighting at the fairs in older times. After 1830 when trade began to increase, presumably due to the easier access to the town, the number of fairs was increased from four to seven each year, held in the months of March, April, June, August, September, October and November.

In those days the fairs were formally opened by members of the Conwy Corporation and there was a procession to the square where the proclamation took place. According to an ancient document, people were free to buy and sell without paying for their stalls. By 1911, the number of fairs had increased to ten per year, but later in the twentieth century the fairs had declined to just two a year, the Seed Fair on 26 March and the Honey Fair on 13 September, these fixed dates going back to medieval times. The fairs are still held on these dates, the only exception being that if the traditional date falls on a Sunday, the fair is moved to Monday, and it has been known to change the date if the Seed Fair occurs at Easter weekend. In the middle of the twentieth century, the Honey Fair became immensely popular and stalls occupied Castle Street as well as High Street, with all traffic in both directions running along Rose Hill Street and Bangor Road. In those days, the fair went on until midnight and were an occasion not to be missed. Sadly, towards the end of the twentieth century, the fairs declined considerably and became just a few stalls in a car park. There was concern that this centuries-old tradition may come to an end, but in the twenty-first century, the fair began to grow again and is once more a popular event that occupies both sides of High Street and Lancaster Square. The Honey Fair is a much bigger event than the Seed Fair and the locally produced honey is very popular. However, the Seed Fair, as its name suggests, sells plant seeds, and particularly seed potatoes. Also, both fairs sell a variety of homemade and locally produced items.

As well as the fairs, there was, in past times, a weekly market on a Friday. At the markets, selling did not begin until a bell was rung. The weekly market has long since

Typical of many stalls at the annual Honey Fair.

ceased, but in its place in recent years, there are occasional sales events on the Quay, such as the Celtic Fair and the International Food Festival, and also the Conwy Food Festival every year in October, which is a very popular event, takes place at locations all over the town.

22. Ferry

From early times, travellers on the North Wales coast met an obstacle when they reached the Conwy River. There was a crossing at Llanrwst, 12 miles away, from early times where a bridge existed even before the seventeenth-century bridge was built, but this represented a long detour in the days of horse travel. A ferry had been operating at Tal-y-Cafn, 4 miles up the river, since Roman times and there was a commercial ferry at this location from the beginning of the fourteenth century. Many travellers preferred to use this crossing rather than cross at Conwy because the waters were calm at Tal-y-Cafn. Also, there was a ford at Caerhun that could be crossed at very low tide. If travellers did not choose these options, then they had to cross the river by ferry at Conwy. There was a commercial ferry from Deganwy to Conwy Morfa (the narrowest part of the river) as early as the twelfth century, and

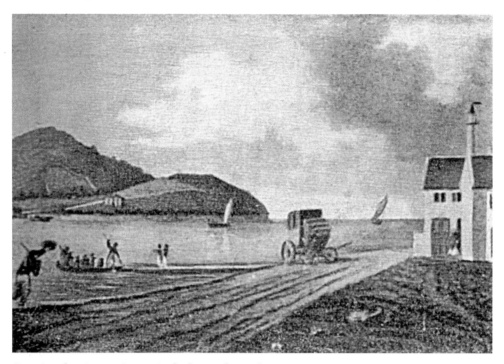

Crossing the river to Conwy in the late eighteenth century.

the route to this ferry from the east was along what is known as Sarn y Mynach (Monk's Causeway), which crossed a stream known as Afon Ganol that flowed through Mochdre to Rhos-on-Sea (once the place where the River Conwy entered the sea). The causeway was so named because the monks used it to travel between Aberconwy Abbey and Rhos Fynach Abbey. The location of Sarn y Mynach is to the east of Llandudno junction, and this part of the junction is still known as Pensarn (head of the causeway).

When Conwy Castle and the town were built in late thirteenth century, the route of the Conwy Ferry was changed to run to the town of Conwy. There used to be a hotel called the Ferry Farm Hotel, where the Llandudno Junction flyover now stands. The hotel, which was used to accommodate travellers waiting for the ferry, was demolished 100 years ago. The ferry had a bad reputation and travellers complained about being kept waiting and about the rudeness of the ferrymen, as well as the dangerous waters that had to be crossed, which resulted in some fatalities. Needless to say, everyone was pleased when Telford's bridge was built in 1826 and so rendered the ferry as no longer necessary – that is, everyone was pleased except for the ferrymen who lost their livelihood, but they received generous compensation. However, this was not the end of the ferry. Nearly 100 years later in 2010, a river taxi service was introduced between Conwy and Deganwy that could be booked by phone at five minutes notice – a better service than the nineteenth-century ferry.

G

23. Guildhall

Although the present Guildhall dates from the mid-nineteenth century, various other buildings have stood on the site since medieval times. The name 'Guildhall' comes from associations with various craft guilds that met in buildings previously on or near this site. Many of the old buildings on the site were burned during times of conflict in the town. Such buildings have been known as Common House, Common Hall, Guildhall, Town Hall and Shire Hall. As time went on, the buildings on the site became used for civic purposes. It is interesting to recall that the method of calling burgesses to meeting was by the ringing of a bell. Any burgesses who did not appear at the Guildhall were fined 2s 6d (12.5p). The Guildhall was rebuilt in 1863 and was extended in stages between 1925 and 1935. It was during these extensions that the present entrance was built. The Guildhall is used today for Conwy Town Council meetings and is also hired by people for various meetings. The Guildhall is also a popular venue for wedding ceremonies and receptions.

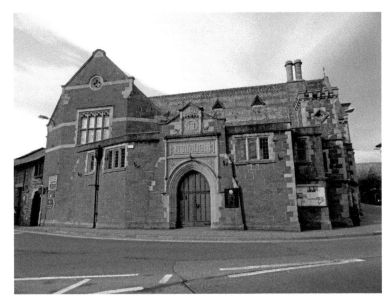

The Guildhall with the name and the Conwy town crest carved on the building.

24. High Street

High Street is the main shopping street of the town and leads from Lancaster Square to the Quay, the lower section being known as Lower High Street. In terms of pedestrians, it is also the busiest street. It has a variety of good-quality shops, restaurants, pubs and cafés, including good-quality gift shops that attract tourists. Almost all of these businesses are privately owned and this adds to Conwy's unique status. While so many larger towns have become faceless and have lost their character, as the chain stores in them are the same in every town one visits, Conwy is different and this is a major factor that draws people to the town. Among High Street's most famous buildings are Plas Mawr and the Castle Hotel.

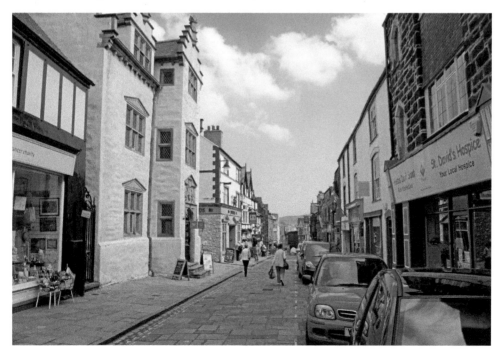

Looking down High Street, Plas Mawr and Edwards's butcher on left.

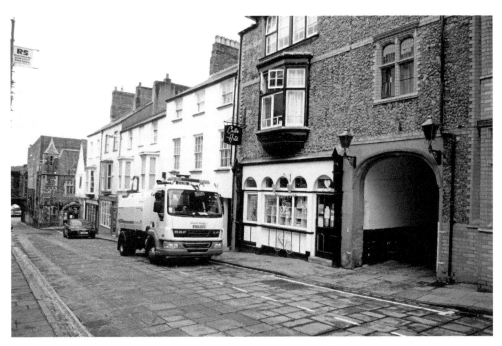

High Street looking towards Porth Isaf, with Castle Hotel on right.

25. Ken Hughes (Conwy's Oldest Fisherman)

Ken Hughes, who was born in Berry Street in 1926, has seen many changes in the life of Conwy. As he was born inside the walls, Ken is a genuine Conwy 'Jackdaw'. His grandfather, originally from Blackpool, came to Conwy almost by accident. He and other members of his family were fishing along the coast and in bad weather they sought shelter in Conwy Harbour. They liked the town and from then onwards they became Conwy fishermen. Ken's wife, Denise, is descended from the Craven family, who also came from Blackpool. As they say, the rest is history and the Hughes and Craven families, together with the Jones and Roberts families, became established fishing families in Conwy. In past times, they built their own boats, so they had confidence that they were seaworthy. In the summer they took tourists on trips on the river and at one time there were twelve small passenger boats based at Conwy.

Ken left school at the age of fourteen and went to work on the trawlers and also on the mussel boats on which he continued to work until he was eighty. His father, William, taught him all the fishing skills and how to rake in the mussels in the traditional way, a skill that has been passed down the generations for hundreds of years, probably since the monks of Aberconwy Abbey. Most of the trawlers have gone from Conwy now but mussel fishing continues. Ken, who often walks down to the

Quay to chat with his old friends, who are also retired fishermen, remembers the names of the fishing boats from the days when there were many more than there are now, names such as *Glenmaye, Eveready, Apt, Reynald,* and *Penover.* Unfortunately, *Glenmaye* was lost near Puffin Island. Fishing is always a hazardous occupation and Conwy fishermen remember with sadness when the fishing boat *Katy* and her young crew, known to their mates as Sam (Rowlands), Cochyn (Hughes) and Robbo (Hall) were lost in 1994. They are commemorated by a plaque on the Quay. In those days, the Conwy trawlers travelled some distance, not just into Conwy Bay and around Anglesey, but further out into the Irish Sea and through the Menai Strait, then south into Cardigan Bay. One fishing boat was called *Manx Beauty*, which means sometimes the boats went as far north as the Isle of Man. Among his memories, Ken remembers taking a famous pop star for a trip on the boat to Puffin Island. As well as the fishing boats, Ken and his friends remember the names of many of the small passenger boats such as *Alice, Sandra, Meira, Glendevore, Satellite, Sunbeam* and *Sylvia.* Today, this tradition is continued with the pleasure boats *Queen Victoria* and *Princess Christine.*

Although there are not as many fishing boats as there used to be, the Conwy fishing community is still a group always ready to tell their story and are supportive of each other, as people who earn their living at sea always are. They are very much at the heart of Conwy, from the past to the present and hopefully into the future.

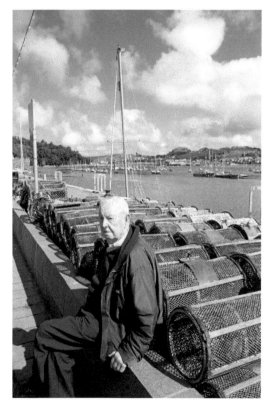

Ken Hughes on the Quay where he often meets his old friends.

I

26. Inshore Lifeboat Station

During the 1960s there was an increase in the number of leisure craft on the Conwy estuary, which meant an increase in boats getting into difficulty while negotiating the tricky sandbanks. It was soon realised that a lifeboat station was needed in Conwy. The station was opened by the Royal National Lifeboat Institution (RNLI) in 1966 and in those fifty years the Conwy station has saved many lives, so 2016 was a very special year for all involved in the Conwy lifeboat station as it celebrated this anniversary.

In 1970, three members of the Conwy lifeboat crew, Ronald Craven, Brian Jones and Trevor Jones were awarded by the RNLI with the 'Thanks on Vellum' for the courage they showed in the rescue of two men from a cabin cruiser in very stormy weather off the West Shore at Llandudno. Trevor Jones has been on the lifeboat crew since the station opened in 1966. Trevor recalls how he was on the last passenger boat to go up the river as far as Trefriw. Sometimes the lifeboat can be called beyond the estuary into the open sea, but at other times rescues can take place in the harbour itself, like the time they rescued an elderly gentleman who fell overboard from his boat. The lifeboat crew can be called to rescue not only humans but sometimes domestic and farm animals. There was one occasion when the crew took the boat about 4 miles up the river to Tal-y-Cafn, on a training exercise when they saw some cattle on the riverbank trapped by the incoming tide. The farmer did not need to call the lifeboat as it was already there. Attempts to lasso the cattle failed but the crew were able to use the boat to herd the cattle to safety, out of reach of the tide. On this occasion, the RNLI inspector was on the lifeboat.

The RNLI receives no funding from government and almost all of its crew members are volunteers who respond immediately to emergency calls. Since its inception in 1824, the RNLI has saved about 140,000 lives. One of the biggest changes in lifeboat crews in recent years has been the full-time occupations of the lifeboat crews. In old times almost all members of lifeboat crews earned their living on the fishing boats, while today they belong to many different occupations and professions. Nevertheless, they have the same commitment to saving lives and the same comradeship among themselves as they work closely together as a team. The lifeboat station is on the Quay, next door to the mussel processing plant and the lifeboat is towed to a ramp and then launched from there into the river. The current lifeboat, named *Arthur Bate II*

and built in 2004, is faster than previous lifeboats at the station and is equipped with modern navigational aids such as GPS. The station has a shop that is open to visitors and is well worth a visit to learn about the vital work of the RNLI.

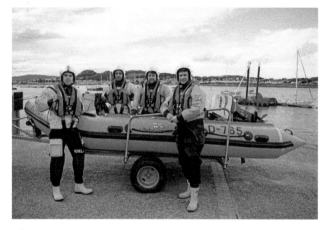

Conwy lifeboat crew preparing to launch on their weekly trial exercise.

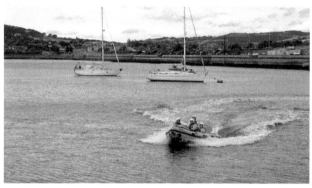

Conwy RNLI inshore rescue boat with the Cob in the background.

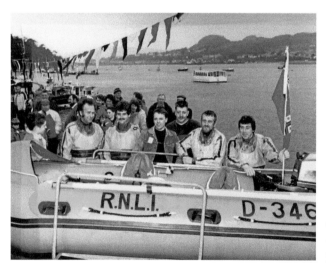

Trevor (fifty years of lifeboat service), Robin (thirty-one years), John, Ricky and Glyn.

J

27. Jackdaws

Jackdaws can be seen all around Conwy. They nest in the towers of the castle and in the town walls. It appears that the town has adopted these birds as its own. This is the origin of people who are born within the town walls being known as 'Jackdaws'. A Jackdaws Society was formed in Conwy in the nineteenth century with membership being restricted to those born within the walls. Sometime later, the society was disbanded but was reformed in 1976, from which time it became an active society and did charitable work within the town and also met socially. During that time the society obtained a ceremonial chair that is believed to have been used at meetings of the original society. The chair is now located in the Guildhall. In 1991, the jackdaws were presented to HM the Queen when she opened the tunnel. However, with the passage of time and the increasing age of the members, and the rarity of home births, the number of Jackdaws declined and in 2011 the society decided to call it a day. Although the society no longer exists, there are still a few around who were born inside the walls and are proud to call themselves Jackdaws.

28. Keith 'Fish'

Local people and visitors to the town will remember Keith Robinson, known locally as Keith 'Fish', who used to sell fish from a stall on the Quay for many years. He was a joiner by trade and he took over the fish-selling business from his grandfather, and then ran his stall for forty years. In the days when there were more fishing boats in Conwy than there are now, Keith used to get his fish directly from the boats at the Quay and his customers very much appreciated this, but in later years the fish came from elsewhere. He was the secretary of the Conwy RNLI for many years, for which service he was awarded the RNLI gold badge. Keith was very popular with all

> IN MEMORY OF
> # KEITH "THE-FISH" ROBINSON
> ## 1940 - 2005
> KEITH TRADED HIS FISH STALL
> AT THIS SITE FOR MORE THAN 40 YEARS.
> HE WAS A GOOD FRIEND TO ALL
> WHO VISITED CONWY QUAY.
> THE MAINSTAY OF THE CONWY LIFEBOAT.
> KEITH HELD THE R.N.L.I. GOLD BADGE
> FOR HIS DEDICATION AND SERVICE
> TO SAVING LIFE AT SEA.

A memorial to Keith 'the Fish' on Conwy Quay.

his customers and he enjoyed a chat with them all and was even happy to chat with people who did not buy any fish. If people had any questions about Conwy, Keith was the man to ask. He was always happy to chat with people about the lifeboat and his genuinely pleasant attitude with people resulted in many generous donations to the RNLI. After decimalisation of currency in 1971, Keith continued to use the pre-decimal terms and it was a familiar sound on the Quay to hear Keith saying to his customers 'That will be 5 and 6 please' (in old money 5 shillings and 6 pence, now 27.5p) or 'Give me 10 bob for that.' (10 bob was 10 shillings, now 50p). Keith died in 2005 and the Quay has not been quite the same since. There is a fitting memorial to him on the Quay, near to the lifeboat station at the place where he had his fish stall.

29. *Kilravock*

The crew of the Conwy trawler *Kilravock* were used to rough seas and dangerous conditions, as are crews of all fishing boats, but in May 1968, *Kilravock* played a prominent part in averting a major disaster.

The 27,000-ton luxury cruise liner *Kungsholm* was visiting Llandudno as one of the destinations on her cruise from New York. Since the liner was too large to berth at the pier, the 314-ton North Wales pleasure ship *St Trillo* acted as a tender. *Kungsholm's* passengers were taken to the pier safely by *St Trillo* for their day trip around the spectacular North Wales scenery. On their return to Llandudno in the evening, they boarded *St Trillo* at the pier to return to the liner and were accompanied by a number of local people who were just making a trip to view the liner, so there were about 400 people aboard. By this time the weather was not good and conditions made it difficult for *St Trillo* to moor alongside the liner and she fouled a propeller on a mooring rope, which disabled one of her engines, and a very short time afterwards the other engine broke down too. This left *St Trillo* drifting helplessly towards the dangerous rocks of the Little Orme. Llandudno lifeboat, which was returning from another call, was soon at the scene and alongside *St Trillo*, but because almost all the passengers were elderly and overcome by seasickness, it was considered too dangerous to expect them to jump into the lifeboat, so a breeches buoy rescue was considered. As this was potentially a very serious incident, it was soon realised that more help was needed so Rhyl and Beaumaris lifeboats were called.

At the same time, the Conwy trawler *Kilravock* was unloading her catch at the Quay and her skipper heard distress calls from *St Trillo* on the radio. He immediately called a halt to unloading and quickly made for Llandudno, just managing to clear the estuary on an ebbing tide. Skipper Jack Williams and his crew, with remarkable skill, got a tow line to *St Trillo* and safely towed the little ship to the pier where her passengers were disembarked. The incident is commemorated by an anchor on Conwy Quay and Jack Williams and his crew saved 400 people from disaster.

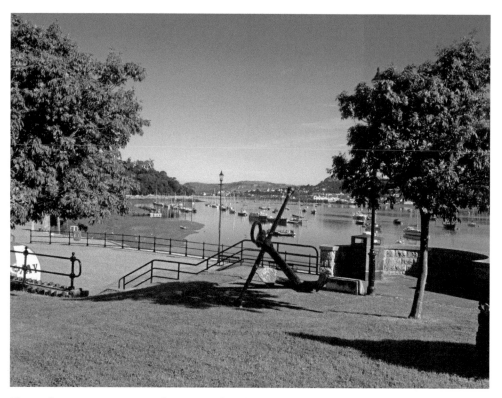

The anchor commemorating the saving of 400 lives by the trawler *Kilravock's* crew.

L

30. Lancaster Square (and the Wars of the Roses)

The square was originally known as the Market Place. This was where most of the commercial activity took place. After he built Conwy, Edward I populated it with wealthy English families and forbade the Welsh either to enter the town or to trade within 10 miles of it. As the saying goes, 'It's an ill wind that blows nobody any good', so traders started to trade in Llanrwst, 11 miles up the valley, which rapidly grew as a market town. However, Edward's decree was not very practical, and although the English settlers inside the walls probably kept a limited number of livestock, fruit and vegetables, it was not easy for them to become self-sufficient, so they had no option but to let the Welsh farmers from the Conwy Valley into the town to trade – and the burgesses who governed the town were more than happy to let them in.

Many visitors to Conwy ask why Lancaster Square is so named. It is not known for certain but the most likely explanation is that the name comes from the time of the Wars of the Roses when Conwy supported the Lancastrian cause. A Welsh 'Robin Hood' known as Dafydd ap Siencyn, who lived in the Conwy Valley and also supported the Lancastrian cause, attacked the town of Denbigh, which supported the Yorkist cause. As an act of retaliation, the Yorkists burned Conwy. The Wars of the Roses ended when Henry Tudor (to become Henry VII), defeated the Yorkist Richard III at Bosworth in 1485. An interesting local connection is that John ap Meredith of Gwydir was summoned by Henry to fight for his cause at Bosworth. The following year, Lancastrian Henry married Elizabeth of York and so united the two houses and symbolised this with the Tudor rose.

After the Wars of the Roses, Conwy was in a bad state and trade had declined, but the dawn of the Tudor era was to bring new prosperity to the town. Also, as the Tudors were of Welsh origin, relations between Wales and England improved and Welsh people were now allowed to live and to trade freely in the town. Today, the statue of Prince Llywelyn ap Iorwerth (Llywelyn the Great) stands in the centre of the square. Although Llywelyn did not found the abbey, nor the town,

his influence must have been great from the time he endowed the abbey with many lands. An early twentieth-century feature of the square was, somewhat unusually, the resident goose Kelly, which was an attraction to locals and visitors alike. Kelly remained a resident on the square until he died in 1925. There was a tavern known as the Boot Inn on the square, which may have existed since the seventeenth century. It was part of two buildings, the other being a temperance hotel. The Boot remained an inn until the mid-twentieth century when it became the very popular Alfredo's Restaurant, specialising in pizza, which it still is today. Also on the square, there was once a temperance hotel and an inn known as the Plough; also two buildings, London House and Manchester House, which are still standing, give an indication of Conwy's links with these two cities, probably initiated by the arrival of the railway.

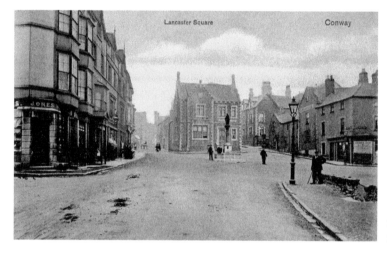

Lancaster Square in the days before motor traffic.

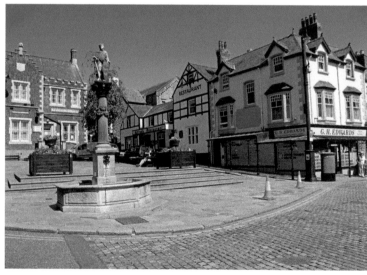

Lancaster Square as it appears today.

31. Liverpool Arms (and Lower High Street)

This pub on the Quay, near to Porth Isaf, has been there since at least the eighteenth century and is thought to be the oldest surviving building on the Quay. In 1828, a sea captain by the name of John Jones took over as licensee and named the pub Liverpool Arms. As well as cargo, he carried passengers from Liverpool in his ship. They probably stayed overnight at the pub and returned to Liverpool the following day. Originally the pub had two entrances, one from Lower High Street for people from the town and one from the Quay for crews of ships and fishermen. It was not until 1907 that the High Street entrance was closed and a new main entrance was built at the Quay. There was once a sailors' hostel next door to the Liverpool Arms. In those days, Conwy was a very busy port, but following the coming of the railway in 1848, the business of the port began to decline as both passengers and goods started to travel by train rather than by sea. John Jones saw the potential of this and gave up his tenancy of the pub in 1851 to work on the railway. He soon became station master of a new station at Colwyn. He and his family are buried in Conwy Churchyard. In Lower High Street behind the Liverpool Arms is the Yacht Club and next to that is Liverpool House, occupied by the popular Chez Illy coffee shop, which serves a variety of coffees and other drinks and snacks. The building is probably named after the Liverpool Arms. The building next door, on the corner of Berry Street, has been the site of a variety of

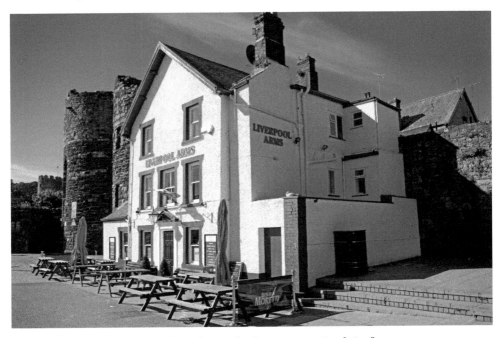

The Liverpool Arms, a popular hostelry on the Quay, next to Porth Isaf.

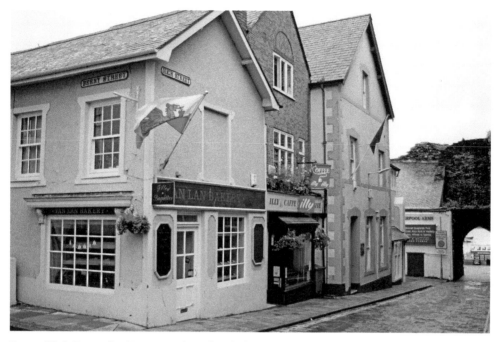

Lower High Street, leading to Porth Isaf and The Liverpool Arms.

shops, until recently an antique shop known as Lovejoy's, but now is a baker's shop with a good selection of bread and cakes.

32. Llywelyn ap Iorwerth (Llywelyn the Great)

It is impossible to visit Conwy without being reminded of Llywelyn ap Iorwerth (Llywelyn the Great). His statue is in the square, and in the summer season many buildings display his coat of arms on flags, and there are streets, houses and buildings in the town named after him. In medieval times, Wales was ruled by princes, each of whom had his own territory. They often fought for the right to control the land, although many of them were related. Llywelyn the Great is so named because he united almost all of the Welsh people and so was able to call himself Prince of Wales. It is believed that he was born in Dolwyddelan around the year 1173, but not in Dolwyddelan Castle, which he built later. There have been some claims that Llywelyn founded Aberconwy Abbey but this is almost certainly not the case, since contemporary records say that the abbey was completed in 1186, which would make Llywelyn too young. By the early thirteenth century he had established himself as Prince of Wales, and this is probably the year that he endowed the abbey with great wealth and gave it much land, together with special rights and privileges. Llywelyn married Joan, daughter of King John of England, who

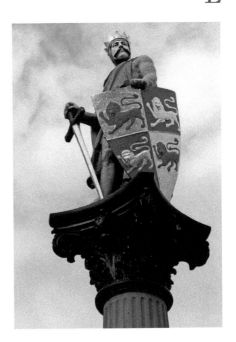

This statue of Llywelyn occupies a prominent position in Lancaster Square.

frequently mediated between her father and her husband. Llywelyn fell in and out of favour with John and with his successor Henry III. Llywelyn died in 1240 in Aberconwy Abbey where he was buried. When the English king, Edward I, crossed the river forty-three years later and moved the abbey to Maenan in the Conwy Valley, the monks reburied Llywelyn there. Following the dissolution of the abbey, Llywelyn's coffin was moved to the Gwydir Chapel in Llanrwst Church, where it remains to this day.

33. Lower Gate Street

Lower Gate Street runs from Porth Isaf (Lower Gate) to Porth yr Aden (Wing Gate). Its most famous building is the Smallest House. The cottages to the right of the Smallest House remain, as well as a larger house that was once the Royal Oak pub. There was also another pub just the other side of Porth yr Aden, known as the Joiners' Arms. To the left of the Smallest House is now a large space with no other buildings until the Liverpool Arms. This space was once occupied by small cottages and also for many years by the printworks of R. E. Jones, who produced the local newspaper *North Wales Weekly News*. The printworks continued to function until the early 1970s when a new purpose-built premises was erected at Llandudno Junction. Lower Gate Street was at one time known as the Strand. An interesting feature of the cottages in Lower Gate Street is the washing lines that are on the beach across the road. This is presumably because the houses are built so close to the walls that there is no space for washing lines at the back, and no doubt there is plenty of breeze next to the river. This is a practice that seems to date back to when the houses were built and some old pictures show these washing lines.

Former Royal Oak Inn (with a veranda over the door), Lower Gate Street.

Immaculately maintained cottages in Lower Gate Street.

Lower Gate Street from Porth yr Aden.

M

34. St Mary's Church

When Edward I built the castle, walls and town of Conwy and moved the monks up the Conwy Valley to Maenan, the abbey church became Conwy's parish church of St Mary and All Saints. Although the church was largely rebuilt on its conversion from abbey church to parish church in the late thirteenth century, parts of the east and west walls are from the original abbey church. In fact, few people realise some parts of St Mary's are older than the castle. The fourteenth century saw further work on the church when the south transept, the two porches and the base of the tower were constructed. The tower was completed in the fifteenth century and inside the church, the very impressive font was constructed in the early fifteenth century. Many natives of Conwy, who became famous later in their lives, including Archbishop John Williams and the sculptor John Gibson, were baptised at this font. The imposing screen was constructed in the late fifteenth century. There are many memorials inside the church, one of the most interesting ones being to the nineteenth-century sculptor John Gibson, who was born in Conwy. It is thought that he developed his skills by drawing some of the inn signs in Conwy. He was hired by many famous people, including Queen Victoria. Gibson died in Rome and was buried there.

Much restoration work took place in the latter part of the nineteenth century and a memorial chapel to commemorate those who lost their lives in the First World War was added in 1921. St Mary's is sometimes known as the 'Westminster Abbey of Wales' because it is the burial place of many of the medieval princes of Wales and other famous people. Although the church is literally in the centre of the town, it is sometimes missed by visitors who just keep to the busy shopping areas of High Street and Castle Street. The church is within a large churchyard where many of the famous people of Conwy's past are buried. There are entrances to the churchyard from High Street, Castle Street, Rose Hill Street and Church Street, which provide a contrasting peaceful scene from these busy shopping streets. Among the famous people from Conwy's past who were buried here is Llywelyn the Great, whose body was moved to Maenan when the abbey was relocated there. On the dissolution of Maenan Abbey, his coffin was moved to Llanrwst. In the sixteenth century, the Hollands and the Wynns were the most influential and wealthy families in the area and Robert Wynn, who built

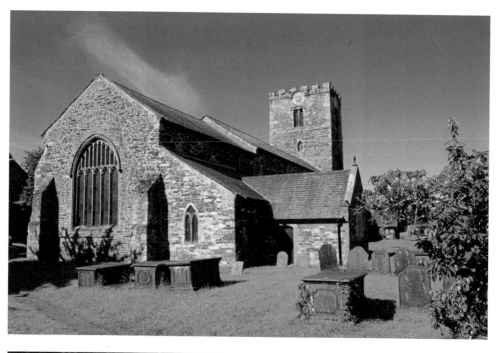

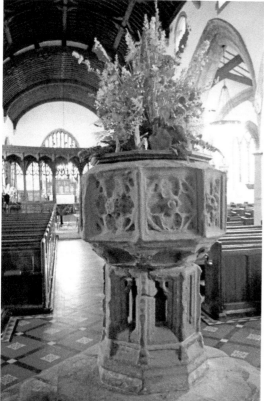

Above: St Mary's Church, on the site of the twelfth-century Aberconwy Abbey.

Left: St Mary's fifteenth-century font where Archbishop John Williams was baptised.

Plas Mawr, is buried in St Mary's churchyard. A sundial near the south porch was built in 1761 in memory of Robert Wynn Jr, presumably the son of Robert Wynn.

The tower of St Mary's houses a clock and two bells. In the days when few people had clocks, these were of very practical use. The bells would be rung when it was time to go to church and, of course, the clock struck every hour of the day and night. Another practical use of the bells was the ringing of the curfew, which for many years was rung at 6 a.m. and again at 8 p.m. This practice was discussed by the Borough Council in 1869 and it was decided that, while the morning bell continued to be useful for people who needed to get up for work, the evening bell served no practical use so should be discontinued. The morning bell continued to be rung each day until 1939.

Although St Mary's has a history going back centuries, it is not a museum. It is a living and active place of worship that welcomes local people and visitors. It is also the principal venue for the very popular annual Conwy Classical Musical Festival in July, which presents high-quality orchestral and vocal music. The week-long festival, with daytime and evening concerts, draws on considerable local talent as well as musicians from further afield.

35. Mussels

Mussels have been fished in the Conwy estuary for centuries and the traditional method of fishing is still used today. At one time, there were ninety mussel fishermen based in Conwy, but now there is only a small number. However, they are highly skilled in the traditional method of collecting mussels, skills that have been passed on from generation to generation of the same families. This involves going to the estuary in a small boat and hand-raking the mussels from their natural habitat.

Conwy mussels are not rope grown or dredged. Mussel fishing takes place only between September and April (or to make it easy to remember, when there is an 'R' in the name of the month). This leaves the mussels free to breed in the summer and allows the mussel beds to settle in a natural way. This means they are larger than most other mussels and have their own special taste, as they grow at the estuary where the pure mountain waters of Snowdonia meet the sea. Mussels are purified before they can be eaten and the town of Conwy has led the way in mussel purification since the early part of the twentieth century. Since the ministry laboratory containing the purification tanks closed in 1999, a new processing plant was built on the Quay, which has all the modern facilities for mussel purification. The mussels are washed, purified for forty-eight hours and washed again. They are then bagged and sold. They are a popular delicacy in local restaurants. It is well worth a visit to the mussel centre on the Quay. Although mussels are only sold in season (September to April), it is also interesting to visit the centre in the summer. In past times Conwy mussels were fished for their pearls, which were sold to quality jewellers in London and other large cities, the mussels themselves being fed to animals. It is said that there is a Conwy pearl in the crown jewels.

Above: Lifeboat Station and Mussel Centre on the Quay.

Below: Trevor Jones, lifeboat man of fifty years, standing at the Mussel Centre.

N

36. 'New' Bridge (1958)

By the 1930s road traffic in Conwy was becoming a serious problem. Toll collection and one-way traffic over the suspension bridge, together with the town's narrow streets, led to traffic congestion. Planners of the day proposed a number of schemes, all of which aroused local opposition. One scheme was to build a new bridge and then take the road onto the Quay, thereby putting the town's fishermen out of business. It would also have involved demolishing a section of the town walls. An alternative was to build a dual carriageway to pass through the town, which would have involved demolishing the suspension bridge and also most of the buildings in Rose Hill Street, including the Guildhall. Local people protested to David Lloyd George, the local MP. He came to Conwy to meet the protesters and, although the Quay route was chosen, it was put on hold.

The Second World War intervened and it was not until the 1950s that further thought was given to the matter. By this time, the traffic congestion was getting worse and the town was beginning to suffer economically, as were other places west of the Conwy River. The severe weight limit on the bridge was becoming a major issue and larger vehicles had to go up to Tal-y-Cafn or Llanrwst to cross the river. This involved negotiating very narrow roads so, in some cases, traffic had to cross at Betws-y-Coed, adding 20 miles to a journey to Bangor, which drove up costs for haulage companies. Bus services into Conwy had to use small, single-deck buses, which also increased costs.

So, as a matter of urgency, a new single-span bridge was built in 1958 next to the suspension bridge. Meanwhile, the plan to take the road onto the Quay was still in situ, but it remained on hold. The new bridge reduced costs for haulage and bus companies but still did not solve the traffic congestion problem despite the introduction of a new one-way traffic flow through the town. Up until this time, traffic travelled in both directions along Rose Hill Street and in both directions under the Bangor Arch. Also, Castle Street and High Street were used for two-way traffic. The new system meant that traffic entering the town from the bridge passed along Rose Hill Street and then out of the town through the Bangor Arch, but traffic in the opposite direction turned left into an improved Town Ditch Road and then continued under the arch into Berry Street and then into Castle Street. At the same time, High Street was made one way from the square to the junction with Berry Street and Castle Street. In the 1980s, the

one-way traffic on High Street was changed to run towards Lancaster Square. Apart from this, the one-way system developed in 1958 continues to the present day.

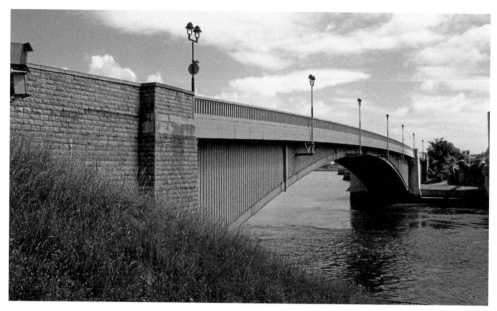

Above: The 1958 bridge looking eastwards.

Below: The 1958 bridge and the suspension bridge looking eastwards.

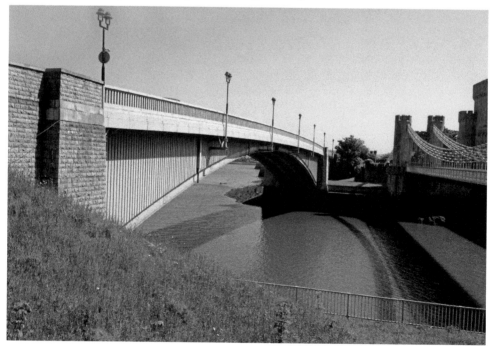

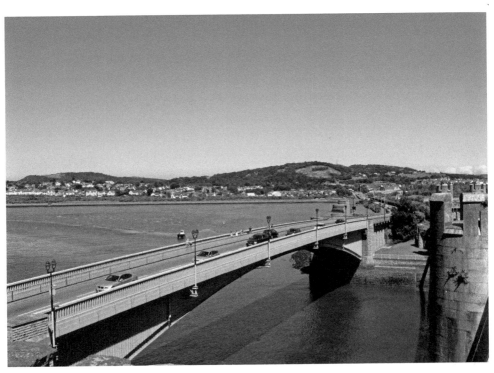

Above: 'New' bridge with Llandudno Junction and Deganwy in the background.

Below: The mountains and the castle form an attractive background to the bridges.

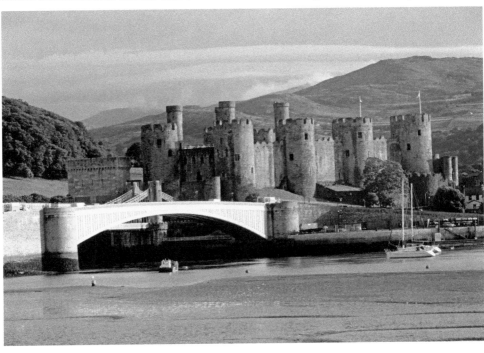

37. Owain Glyndwr

Owain Glyndwr was born into a noble Welsh family in the second half of the fourteenth century. He served in the military service of the king of England, but later returned to his native Wales where he spent some years living peacefully. Owain had been a supporter of Richard II (*see* 43. Richard II), so he was not pleased when Richard, who was popular in Wales, was betrayed by Henry Bolingbroke. Baron Grey of Ruthin, who was a supporter of Bolingbroke, took some land from Glyndwr and refused to return it. These events caused Glyndwr to take action and he rapidly gained support from Welsh people. In 1400, he set fire to Ruthin as retaliation to the treatment he received from de Grey and also set fire to Conwy in retaliation for Richard's betrayal. The Tudors from Anglesey, supporters of Glyndwr, took Conwy Castle without any fighting while the garrison were in church on Good Friday 1400, and left the castle with virtually no defence. The Tudors easily gained entrance and held the castle for six months. Over the next few years, Owain's cause gained increasing support throughout Wales and many places were burned. Glyndwr's cause also received French support. He became Prince of Wales and, after taking Harlech Castle, he set up a parliament at Machynlleth in 1404. At that time, it appeared he would gain control of Wales, and probably would have done so if the French troops had not returned home to deal with domestic problems. Owain Glyndwr was never captured and it is thought he died a peaceful death but in isolation, as his wife and daughter died in the Tower of London.

P

38. Palace Cinema

In the days before television when only the very wealthy had cars, every town had its cinema and Conwy was no exception. The Palace Cinema in High Street, which opened in the mid-1930s, was designed by famous Colwyn Bay architect Sidney Colwyn Foulkes. Although many people just walk past it without giving it much thought, it is one of the most interesting twentieth-century buildings in Conwy and it is well worth stopping a while to look at it. The building gives the impression of being older than its eighty years, and this is mainly due to the stepped gables that copy the style of the nearby and very much older Plas Mawr. A closer look will reveal a very interesting 'window', which depicts, throughout its length, peacocks and squirrels carved in cast iron. The cinema was not the first building on this site and it is thought that at least two buildings preceded it, one being the Metropolitan Bank. From the time of its opening, the cinema thrived and it was particularly popular during the Second World War and a few years beyond. However, by the mid-1950s, more and more people had a television set in their homes and attendances at the Palace, together with other cinemas, began to decline. By the late 1960s, when home television had

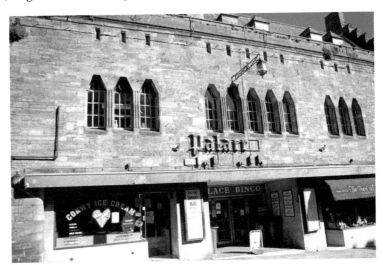

The former Palace cinema in High Street, built in the 1930s.

'Peacocks' and 'squirrels' carved in wrought iron at the former Palace Cinema.

more or less become universal, the decline in cinema attendance accelerated. By the 1970s, the Palace was looking for other ways to earn its keep, and concerts, theatre performances and bingo were introduced in addition to the screening of films. By the beginning of the 1980s, the Palace went over exclusively to bingo, but this in turn came to an end in 2012. Part of the ground floor is now used by the Conwy Ice Cream shop and the Pearl of Conwy shop, but otherwise it is not used. The first floor is occupied by the popular Amelie's restaurant.

39. Betty Pattinson

Betty Pattinson is one of Conwy's best-known residents. She was born in the town and is one of the oldest Jackdaws. Betty, like so many of Conwy's Jackdaws, is from an old fishing family. She recalls the days when the fishing industry in Conwy supported 200 families. Betty began her working life at Porters' solicitors in the town's Castle Square, and later she worked in local government in Bodlondeb. Betty has been at the heart of civic life in Conwy for more than half a century. She has been mayor of Conwy Town twice, an appointment that traditionally means also being the constable of Conwy Castle, and she has also been mayor of Aberconwy Borough.

The wellbeing of the people of Conwy is important to Betty and though she is now retired from council work, she still takes a genuine interest in the community, and

Betty Pattison as mayor and also constable of the castle.

the social and cultural life of the town matters greatly to her. It is an indication of her tireless community work that she was awarded the OBE in 1986. During her time as a councillor, Betty met a number of significant people, including many members of the royal family, the highlight of which was when she was presented to HM the Queen at the opening of the Conwy Tunnel. Betty loves chatting about Conwy's history but looks to the town's future with interest and also sometimes with concern. She recalls how she, together with other Conwy residents, had in the past fought against many proposed developments, which, if they would have been approved, would have made Conwy look a very different place from what it is today. Betty has written two books about Conwy, which are well illustrated with interesting pictures of people and places in the history of the town.

40. Plas Mawr

It took a long time for Conwy to recover from the violent times of the fifteenth century, but the recovery brought a new prosperity to the town and there is no better example of that than the impressive Plas Mawr in Crown Lane/High Street. Plas Mawr (The Great Mansion) was built in 1576 by Robert Wynn at a cost of £800. Although it is difficult to compare prices today with those of four and a half centuries ago, it is interesting to note that renovation of the building to its original state by Cadw in 1993 cost over £3 million. Robert Wynn must have been very wealthy. When he returned from military service, he married Dorothy Griffith, also very wealthy, and they decided

to build a new home for themselves in Conwy, which had by that time become a very fashionable place to live. He bought an existing house and some adjoining land and built Plas Mawr in stages between 1576 and 1585, where he and his wife entertained the local gentry on a lavish scale with no expense spared. The decorating style made considerable use of colour. As Robert Wynn owned many of the farms in the area, there was no shortage of produce for his family and their guests, and the house had its own bakery, dairy and even brewed its own beer. After he died, the house was occupied by his descendants, but passed to the Mostyn family in the late seventeenth century, by which time it had ceased to be a family home. They let it to various tenants over the years, its last tenants being the Royal Cambrian Academy of Art.

In 1993, Cadw took over the building and restored it to its original appearance. It is open to the public and well worth a visit to see the authentic recreation of its rooms, including the kitchen. It takes some time to look around Plas Mawr to appreciate the redecoration of the rooms in their period style. It is easy to understand that soon after it was built, Plas Mawr had eclipsed the castle in importance, but just as in the castle, a little imagination can help to take us back through the centuries. It is thought to be the best-preserved Elizabethan townhouse in Britain. The distinctive design of Plas Mawr with its stepped gables was, in the nineteenth century, copied in the architecture of other nearby buildings such as the police station, the Castle Hotel, the original railway station (now demolished), and also the arches incorporated into the walls when the railway was built.

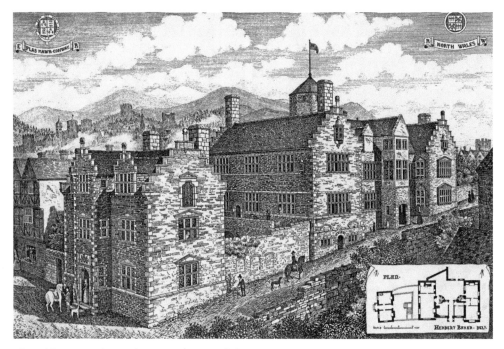

This old picture shows the massive size of Plas Mawr.

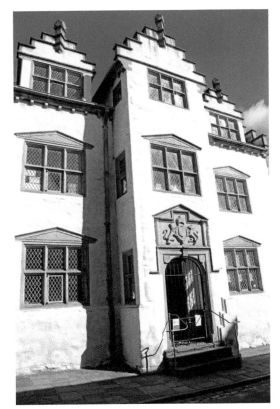

Right: Plas Mawr as seen from High Street.

Below: The Elizabethan coat of arms and crests of Robert Wynn and Ednyfed Fychan.

41. Quay (and Harbour)

Most visitors to Conwy make for the Quay, where they can enjoy a leisurely walk amid stunning scenery, but in past times there was little time for leisure here as this was a very busy commercial port. In the days of Aberconwy Abbey, most supplies came by sea and when Edward I built the castle and walled town, he regarded sea communication as important to bring in supplies and for military purposes. By the eighteenth century Conwy had become an important port and ship building centre. There were reports of £50,000 worth of oak floated down the river from Gwydir in a period of less than ten years. This was used for building ships and the bark was used for tanning leather and much of it was exported. Many furnaces were set up near the river and the Furnace Tearoom, at the Welsh Food Centre at Bodnant in the Conwy Valley, is at the location of an eighteenth-century furnace. Also, a ship that traded between Conwy and Chester was named *Conway Furnace*. The exports of timber were so great that cheaper timber had to be imported for fuel.

In the eighteenth century, there were no roads as we now know them so imports and exports kept Conwy harbour busy. A variety of cargo was exported: oats, wheat, barley, and vegetables, which went to Ireland, Scotland and Liverpool. There were also imports of seed potatoes, which were planted locally and then, when they had fully grown later in the year, they were exported. This may well be the origin of the Seed Fair, which sells seed potatoes to this day. As well as food exports, there were other cargoes, such as potash for the soap works at Warrington. Slate was a major export that would be carried down the river from Trefriw in small boats and then transferred to larger sea-going vessels to be shipped to all parts. Imports included coal, iron, salt and earthenware. In 1833, a stone quay was built, which meant that ships could load and unload their cargoes more easily. Some of the most impressive ships to visit Conwy were the three-masted barques, many of which brought timber from the Baltic.

When the railway came in 1848, Conwy's shipping trade was seriously affected; for example, in just twenty-five years slate exports declined from 27,000 tons to 6,000. However, the trading ships did not cease completely as many bulky cargoes could be transported more easily by sea. Timber ships were still coming up the river at the

beginning of the twentieth century and a timber ship came to Deganwy as late as the 1930s. By this time, the only commercial boats seen on the river were trawlers and mussel boats, and now the trawlers have generally gone but the mussel fishing business continues. Conwy was also a harbour for passenger ships and there was a regular service sailing to and from Liverpool as well as the paddle steamers that called at Conwy on their way from Deganwy to Trefriw. Small boats still take people on trips to the estuary and for a short distance under the bridges. Most of the boats now seen at or around the quay are leisure craft. There were once many cottages on the quay, but most of them have now been demolished. These were homes for those who worked in the fishing industry. Over the years the quay has been less able to accommodate larger ships. The building of the Cob, the suspension bridge, the railway bridge and the 1958 road bridge caused changes in the sandbanks and deposits of sand at the quay. The tunnel has also caused changes to sandbanks, which can change by the day.

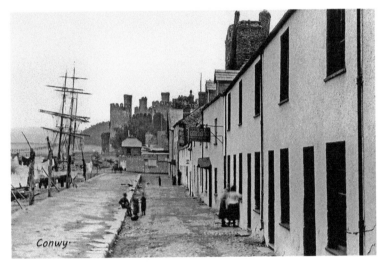

Three-masted barques were once regular visitors to Conwy.

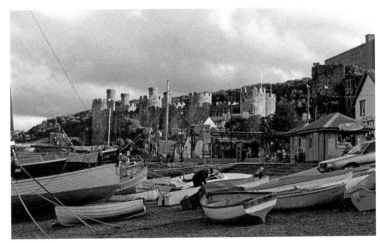

The castle and Benarth Woods form an impressive background to the Quay.

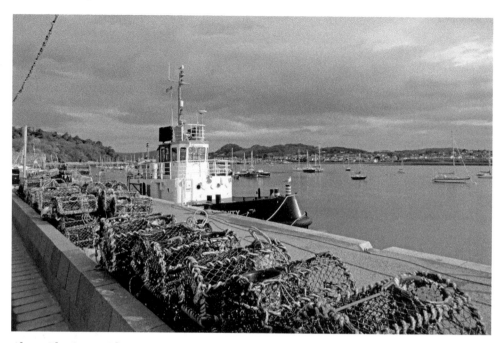

Above: The Quay with Deganwy (right) and Bodlondeb Woods (left) in the distance.

Below: Sunlight and shadows at the Quay.

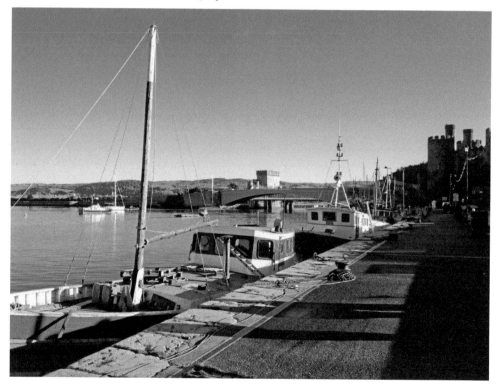

R

42. Railway Station

The coming of the Chester and Holyhead Railway to Conwy in 1848 made an enormous difference to the life of the town and indeed to all of the North Wales coast. Conwy, one of the original stations, was very much a principal station, so a substantial station building was designed by Francis Thomson, who designed most of the original stations on the line. When the line opened, Conwy was the only station (with the exception of Aber) between Abergele and Bangor. Despite the cramped location, the station also incorporated sidings for goods wagons. In the early days of the railway there was concern that trains could cause damage to one of the castle towers already in a bad state of repair. The tower was repaired at the expense of the railway company.

When the Chester and Holyhead Railway was built, Llandudno was just a hamlet on the Great Orme and Colwyn Bay was not even thought of. By 1858 Llandudno was rapidly developing into a major seaside resort and was considered important enough to warrant its own railway station, so a branch line was built. Originally, trains to and from Llandudno commenced at Conwy, until the first Llandudno Junction station was built later, but Conwy was still considered the principal station. Another branch line was built in 1863, initially to Llanrwst and later it was extended to Betws-y-Coed and Blaenau Ffestiniog. It is interesting to note that the original plan for the Conwy and Llanrwst Railway was for the line to be on the west bank of the river. As rail traffic continued to increase, a new five-platform station was built at Llandudno in 1892. Five years later, a new Llandudno Junction station was built, which was much larger than the previous one. From this time, Llandudno Junction became the principal station and Conwy station began to decline in importance, although in the early part of the twentieth century, there were still about twenty staff employed at Conwy. It is said that a nineteenth-century stationmaster at Conwy grew lilies on the platform. Such practices today would enable a station to be considered for the best kept station award. As time went on, express trains ceased to stop at Conwy and there was a further decline in the usage of the station until, on the recommendation of the Beeching report, Conwy station was closed in 1966 as it was considered too close to Llandudno Junction. However, the mail train from

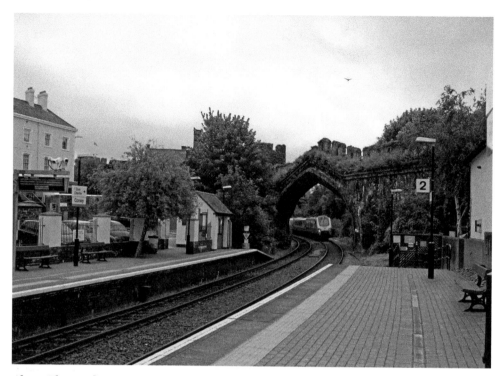

Above: The London to Holyhead express speeding through Conwy station.

Below: The castellated arch built in 1848 for the railway.

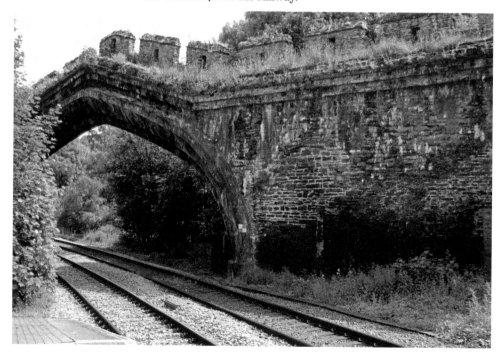

Holyhead to Birmingham still stopped at Conwy until closure, reminiscent of the days when Conwy was the main post town for the area. A few years later the station buildings were demolished. The closure of Conwy station was not well received, particularly as road traffic was increasing and a rail link would have permitted an easy access to the town when the roads were clogged with traffic. Following years of pressure by local individuals and groups, a new but basic station was built in 1987 and now Conwy is once more on the rail map. Also relating to transport, the area in front of the railway station has been for a very long time the terminus of bus services in Conwy. There was, until the early 1970s, an office of the former Crosville bus company in a small 'hut' opposite the station.

43. Richard II

In medieval times, kings did not automatically ascend to the throne by a pre-defined order of succession, although hereditary right usually played some part in their claims. In practice they had to fight their rivals to win succession to kingship and continue to fight while they held the office of king. Richard II, who later in his reign had an association with Conwy, was just ten years old when he became king and a number of powerful lords ruled on his behalf. These lords also fought among themselves as they had their eyes on the throne. After a difficult period in Richard's early reign, he later regained control and ruled in his own right. Richard and his cousin Henry Bolingbroke had been great friends, but later in life became enemies. Richard banished Henry to France and confiscated his lands. Later, when Richard was in Ireland, Henry took advantage of his absence by returning to England and he gathered many supporters from the Lancastrians who wanted the Lancastrian Henry to be king rather than the Yorkist Richard.

In 1399, Henry sent a message to Richard in Ireland to say he wanted to see him to claim back his confiscated land, which was his by right. At first, Richard ignored the message and stayed in Dublin, but when news got to him that Henry's troops were increasing in number, he decided to cross to Wales and seek shelter in Conwy Castle. By this time Richard had lost almost all his support and agreed to meet Bolingbroke's confidant Percy, Earl of Northumberland, in the castle, where Percy told Richard that Bolingbroke had no claims on the throne but just wanted his land restored and that Henry wanted to meet him at Rhuddlan and then to travel to London together as friends. Percy swore an oath to this effect at the altar of Conwy Castle's chapel. Richard agreed and rode out for Rhuddlan with Percy's party having ridden on ahead, but Richard had been tricked. Contemporary accounts tell us that he was captured by Bolingbroke's troops beneath a rock by the sea about 5 miles east of Conwy, a clear reference to Penmaenrhos headland near what is now Colwyn Bay. After his capture, Richard was taken, not to Rhuddlan but to Flint, where he surrendered to Bolingbroke, who later took the throne as Henry IV.

44. Rose Hill Street

It is likely that this street, which leads from the castle to Lancaster Square, was once known as Horse Mill Street because of the mill in this area. Other suggestions are that there were many gardens in this area and many fruit trees. When the walls and the town were built, there was plenty of empty space as the original houses by no means filled the area inside the walls, so many gardens were built. Many of these were probably in existence until the nineteenth century when many new buildings were erected to fill all the empty spaces inside the walls. One of the most interesting houses in Rose Hill Street is Castell Mai. This large house was once owned by friends of former Prime Minister David Lloyd George, who occasionally stayed there. Next door is the Methodist church, where the famous preacher and author W. E. Sangster was once a minister. During recent years, this church has been refurbished and now has modern audiovisual facilities. Next door to the Methodist church is St Mary's Church Hall. The red-brick building next to this is owned by the local authority and is used as the official Tourist Information Centre, which also houses an interesting exhibition. This building was formerly the Registry Office. Across the road from here is a large car park, where there were once tennis courts and the vicarage garden, the old vicarage, probably built when the horse mill was closed, was also at this site near Porth-y-Felin. The walls can be accessed from this car park. There was once a pub known as the Plough in Rose Hill Street, opposite the railway station, and in the same area there was a bakery and a water pump.

The Methodist church, St Mary's Hall and the Tourist Office in Rose Hill Street.

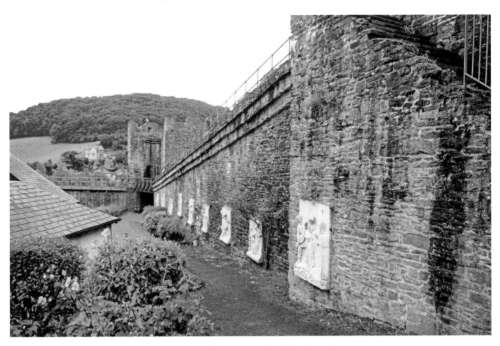

'Stations of the Cross' affixed to the walls at St Michael's Church.

45. Rosemary Lane

Rosemary Lane leads from Lancaster Square over a railway bridge and continues to the town walls. The street contains a number of cottages and at the top of the street is St Michael's Roman Catholic Church, built in 1915. An interesting feature at the church is a series of marble plaques forming the 'stations of the cross'. Although this feature is to be found in many churches, it is unusual here that the plaques are outside the church, rather the inside. They are in fact attached to the town walls, except for one that is attached to the church wall and faces the others. They are thought to have been carved in Milan especially for Conwy and they appeared in Conwy in 1932. Around the corner is a statue of the Virgin Mary. The church was designed by Rinvolucri, an Italian architect who settled in the area. He also designed a very unusual church in the shape of an upturned boat in Amlwch on Anglesey. When Rosemary Lane reaches the walls, it bears right into the top of Upper Gate Street by Porth Uchaf.

46. Royal Cambrian Academy of Art

North Wales, with its impressive coastal, mountain and valley scenery, has attracted artists since early times. The artist movement began in Betws-y-Coed, 15 miles up the Conwy Valley where they set up an artists' colony, but as Betws became more

The Royal Cambrian Academy of Art, formerly Seion Chapel, in Chapel Street.

popular with tourists in the latter part of the nineteenth century, the artists moved down the valley to Trefriw, Llanbedr and Rowen where it was quieter. By 1881 the artists' colony had grown and they set up an organisation to support the work of art in Wales. The following year, the organisation was given the title Royal Cambrian Academy of Art after Prime Minister William Gladstone made a successful request to Queen Victoria to be a patron and therefore the name 'Royal' could be used. Gladstone had connections with North Wales as his home was at Hawarden in Flintshire and he visited Penmaenmawr for his holidays. At first, exhibitions of paintings moved around different locations, the first being in Llandudno. The following year it was held in Rhyl and two years later in Cardiff. In 1885, the Mostyn family, who at that time owned Plas Mawr in Conwy's High Street, offered the academy a tenancy for a permanent exhibition in the building. The RCAA remained in Plas Mawr until 1993 when they moved the art gallery to the disused Seion chapel next door to Plas Mawr. The gallery is open to the public at certain times.

S

47. Seagulls

Every resident and every visitor knows about Conwy's seagulls. These large birds, usually herring gulls, are everywhere in the town. To many who visit the coast on holiday or for a day out, the seagulls are in integral part of the visit and people have thought for many years that it is all part of a seaside holiday to feed the seagulls. However, the seagulls think that any food they see in anyone's hand is for them, regardless of whether the person intends to feed them or not. This has now become bred into them so they fly around looking for every opportunity to find food. On a warm sunny day, many people enjoy eating fish and chips or ice cream in the street, but the seagulls are clever, they know where ice cream and chips are served so they perch on lamp posts near the takeaway outlets and wait for people to come out of the shop with their food, and within seconds they steal it! Locals and regular visitors to the town are used to this, and keep an eye open for the seagulls, but many visitors are taken by surprise. Efforts have been made to discourage seagulls, one of which was to introduce hawks (connected to a lead), not to attack the seagulls but to deter them, but the seagulls soon realise the hawks are no threat so they are not deterred. The best approach is for us not to feed the seagulls, and hope they get the message that our food is not for them.

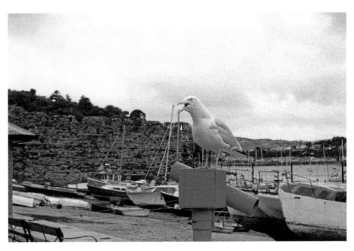

A hungry seagull looking for food.

48. Smallest House

Today, it is not easy to find land to build on and land is usually expensive to buy. In many ways, things have not changed much, which gives us the reason for the building of the smallest house in Great Britain on Conwy Quay. It is one of the most popular of all the tourist attractions in the town and even for people who only have a short time in Conwy, there is always time to visit the Smallest House. As it appears now, it gives the impression that it has been added on to the terrace that adjoins it, but this is not true. As time went on, there was little, if any space remaining to build inside the town walls, so people began to build houses against the walls on the outside. A number of terraces were built and there was a gap between two of these terraces. It was in this gap that the Smallest House was built, not as a tourist attraction but as a practical residential dwelling. It measures just 1.8 metres (72 inches) wide by 3 metres (122 inches) high. Despite its small size, the house contains all the basic amenities. There is a water tap under the stairs, a fireplace from which the house was heated and the cooking was done, and underneath a settle there was a coal bunker. The stairs ascend to a small bedroom with one single bed, a dressing table and a wash stand. The last person to occupy it was a fisherman by the name of Robert Jones, who was 1.9 metres (6 foot 3 inches) tall, who vacated the house when it was condemned in 1900.

The then owner of the house, another Robert Jones, was considering what to do with the house when Roger Dawson, editor of the *North Wales Weekly News,* had a thought that this tiny house might be the smallest house in Britain. He contacted other newspapers and, with their help, a search began all through the land to measure other tiny houses. Robert and Roger travelled some distance to do this and no other house could claim to be smaller. The claim has for a very long time been verified by the *Guinness Book of Records.* As they say, the rest is history and this fascinating little house is one of Conwy's premier attractions and almost everyone who visits it has a picture taken with one of ladies in traditional Welsh costume, who must now be world famous. (*see also* 57. Margaret Williams)

The Smallest House when there were houses on both sides of it.

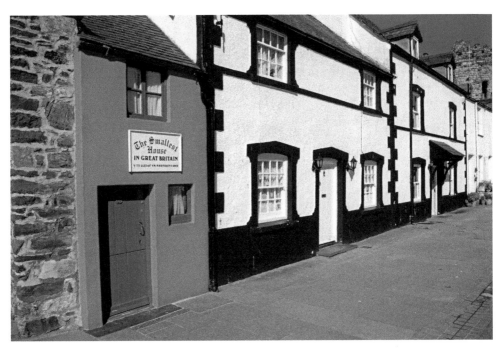

Above: The Smallest House in Lower Gate Street.

Below: The Smallest House is very close to the town walls and tower.

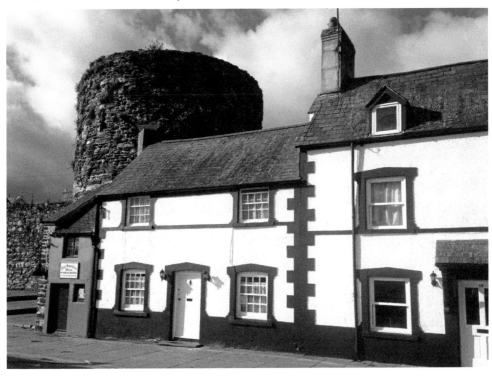

49. Tower Coffee House

This tower at Porth Fach, linking the Quay with Castle Square, is unusual in that it is one of the few towers that has internal fittings. Those who climb the stone staircase to enter the coffee house will find a circular room where they can enjoy their coffee. Also inside is a wooden staircase that leads to the ground floor. This tower has had many uses in its long history, since it originally served as a watchtower for the postern gate, Porth Fach. 'Postern' means a gate of less importance, hence the Welsh name 'Porth Fach' (little gate). It was at one time home to Conwy's Roman Catholic church until it moved to Rosemary Lane in 1915. It then became a solicitor's office, together with Vardre Hall next door. Former Conwy mayor Betty Pattinson worked there and remembers the time when people came there to pay child maintenance allowances. At the present time, the tower is a coffee house. Like many other old buildings in Conwy, the tower has its share of ghost stories. It is said that the ghost plays tricks on people with keys and locks. The current owner took a photograph of this.

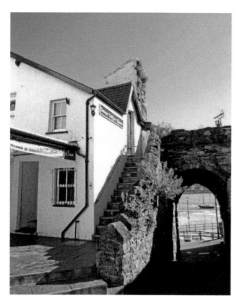

Tower Coffee House is inside one of the towers in the walls.

50. Town Ditch

Today, Town Ditch Road is busy with traffic passing through the town from west to east. Originally it formed part of the ditch beside the walls. It was at one time a quiet road and little more than a track, especially before the Berry Street arch was built in the very early twentieth century. There used to be a number of buildings on the road. These buildings served such diverse purposes as a fire station, an ambulance station and a mortuary. When these buildings were demolished, it left an open and impressive view of the town walls from the bottom of Town Ditch Road to the top of Mount Pleasant.

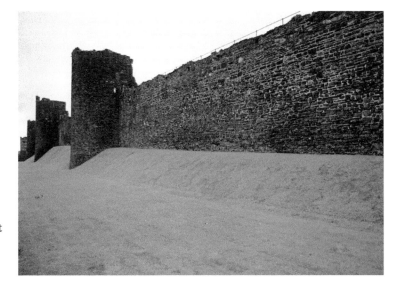

The massive height of the walls is evident from the Town Ditch.

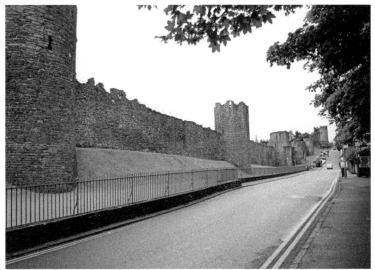

A long stretch of the walls from Town Ditch to Mount Pleasant.

51. Tunnel

By the end of the 1960s, traffic congestion had become unacceptable and, in the summer, massive traffic queues built up outside Conwy, and both Conwy and Colwyn Bay were becoming strangled with traffic. A flyover to replace the railway crossing at Llandudno Junction was built in 1969, but this did little to relieve traffic congestion in Conwy, which had become not a town to visit but a town to avoid. This had a serious economic effect on the town. By this time, it had become clear that a more radical solution was needed to take through traffic out of Conwy. In the late 1960s a major traffic study of the Conwy/Colwyn Bay/Llandudno (abbreviated to COLLCON) area was initiated. Drivers on the road and people in their homes were interviewed. It was generally agreed that a new river crossing was needed but there was much controversy about the two routes that had been proposed. One proposition was for a large bridge over the estuary at Deganwy and the other was for a large bridge just south of the castle, which would have dominated the castle and part of the walls. The local opposition was so great that a public enquiry was called. Eventually, both schemes were abandoned in favour of a tunnel to cross the river from Llandudno Junction to the Morfa.

Work on the 1,090-metre-long tunnel commenced in 1986 and 10,000 square metres were excavated. The spoil was used to develop the RSBP Conwy bird sanctuary on the opposite side of the river. The tunnel consists of six prefabricated units each weighing 30,000 tonnes, which were floated out into the river, a process that took two years. The tunnel, which cost £190 million and is expected to last for 120 years, was completed in 1991 and opened by HM the Queen. An arch on the coastal path commemorates the occasion. So Conwy could breathe again, and the effect on the town was immediate. People came to Conwy again and businesses began to thrive. History has shown that the right decision was made.

U

52. Upper Gate Street

Upper Gate Street, which leads from Porth Uchaf (Upper Gate) to Bangor Road, is a narrow and usually quiet street today compared to many of the other streets in the town. However, in early days, Upper Gate Street would have been the busiest street in Conwy. Porth Uchaf was the main entrance to the town and in past times horse-drawn traffic along the street would keep it busy every day from the time it was built until the nineteenth century. It is no surprise, therefore, that inns and shops were built in this street from very early days. There was also a smithy and a bakery. By the mid-nineteenth century, Upper Gate Street became much quieter as through traffic now entered and left the town by Telford's bridge at the eastern end and the Bangor Road arch at the western end. Now all the inns, except for the Albion, have gone and the street is mainly residential. At one time there were some thatched cottages in the street but these have long since gone.

Right: An early nineteenth-century inn on Upper Gate Street.

Below: Upper Gate Street looking towards Porth Uchaf.

53. Vardre Hall

This large building opposite the castle, now The Knight Shop, is believed to have been built as Plas Vardre in the mid-nineteenth century. The land on which it was built was leased from the Dowager Lady Erskine by William Fitzmaurice. By the late 1860s, the building was bought by a solicitor, William Jones, who used it both as his office and his home. In later years, it continued to be used by solicitors, the last occupants being Porter & Co., who ran their business from there until 1972. Porters also used the tower building next door. After this, Vardre Hall became a restaurant but closed in 1994. Seven years later it reopened as Knights Gone By and is now known as The Knight Shop. This is a fascinating shop and well worth a visit and you might even find your family coat of arms there, or trace your ancestry. Like many other locations in Conwy, there are ghost stories. In this case the ghost is meant to be connected with the civil war, but the house was built more than 200 years after the civil war, so if the stories have any foundation, they must relate to the site rather than the building.

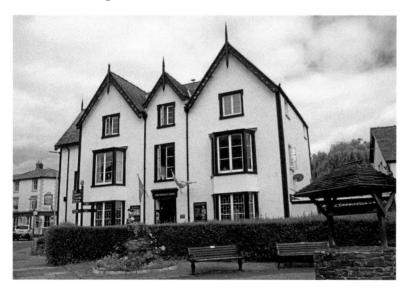

Vardre Hall, which is now The Knight Shop.

W

54. Walls (With Their Gates and Arches)

Conwy town walls were built as a single project with the castle in 1283–86. The walls have been preserved and Conwy can boast one of the most complete circuits of town walls anywhere in Europe. It is no surprise that the walls, as well as the castle, have world heritage status. The walls are open to the public, but care is needed when walking along them, and also a reasonably good head for heights. The view from the walls presents a very different aspect of the town. The walls have twenty-one towers and originally there were just three gates.

54a. Porth Uchaf

Porth Uchaf (Upper Gate) was the main landward entrance to the town. It has twin towers and originally had a portcullis that crossed the ditch. It was the most strongly defended of the three gates as it was the most frequently used. Many of the provisions that came into the town from the Conwy Valley came through this gate. In the nineteenth and twentieth centuries, a small arch was cut into the wall at this point to enable safer pedestrian access as vehicular traffic increased.

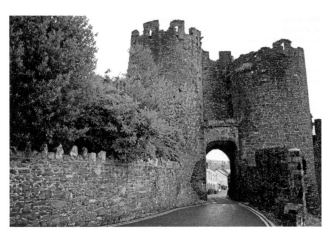

Porth Uchaf, the most important of the original three gates.

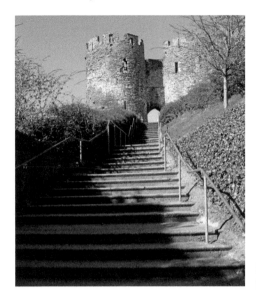

Porth-y-Felin, one of the original gates, led to
the mill.

54b. Porth-y-Felin

Porth-y-Felin (Mill Gate) was also defended by twin towers, which are still standing.
As its name suggests, this gate led to the mill by Gyffin stream. Today, this gate is used
by pedestrians only and provides a useful route to and from a large car park. This is
an impressive walkway and shows the massive walls to their full extent.

54c. Porth Isaf

Porth Isaf (Lower Gate) is the smallest of the original gates and is at the point where
Lower High Street leads to Lower Gate Street on the Quay. This also was defended
by twin towers, still in situ, but it has been altered and is the least-well preserved of
the original gates. As more commercial shipping came into Conwy, this gate became
busier with imports and exports. The stairs on these original towers would have
initially been constructed of timber.

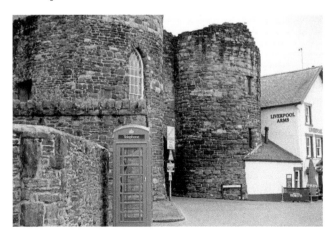

Porth Isaf, an original gate
that led to the harbour.

54d. Porth Fach and 54e. Porth yr Aden

Porth Fach (little gate) and Porth yr Aden (wing gate) were the next two gates to be built. Both of these gates lead to the Quay and they date from early times. They are known as posterns, meaning they were back gates or of less importance than the three original gates. They both have pedestrian and vehicular access. Porth Fach leads to the Quay from Castle Square. It has been altered and enlarged so little of the original remains. A war memorial was built near Porth Fach in 1921, but later it was moved to Bodlondeb. At the other end of the Quay is Porth yr Aden and at this point a spur of the walls enters the river. This was built to protect the harbour as well as forming a military defence. This gate was altered and enlarged in later years. Originally there was a tower at the end of the spur but the effects of centuries of tidal sea water destroyed it.

Porth Fach, an ancient gate that led to the river.

Spur of the river, at Porth Aden (*see* page 49).

54f. Nineteenth- and Twentieth-Century Gates and Arches

As the nineteenth century dawned and the road and rail bridges were built, a way was needed to bring traffic (then horse drawn) into the town from the road bridge and out of the town towards Bangor, so more arches were built into the walls. Telford built an arch into the walls for his new road to get access into the town from his 1826 suspension bridge. He also built toll houses, one at each end of the bridge. As early as the 1930s, there was traffic congestion at this location and, in 1934, part of the wall was breached here. This is the only place where the walls have been breached. Until that time, the town's fire station was located here until it was moved to Town Ditch Road. This created more space in Castle Square and for many years there was a car park in front of the castle. When the 1958 bridge was built, Telford's arch and the adjacent toll house were demolished, but the toll house at the other end of the bridge was retained, and remains there to this day. Also at this point, a small pedestrian arch was built in the late nineteenth century. This is still in use and provides a walking route from the town to the 1958 bridge. The road then went through Rose Hill Street and the square, and a new arch was cut into the walls through which the road left the town. This is known as the 'Top Arch' or the Bangor Road Arch. It is clear to anyone looking at this that Telford made a number of changes to this as its towers have a noticeably different appearance from the other towers in the walls. Later, a small pedestrian arch was cut into the walls at this point, and a second pedestrian arch was cut into the walls at a point accessed from Upper Gate Street, which leads to the Mount Pleasant car park. The imposing building near the Bangor Road Arch was once Conwy's post office.

Stevenson built the railway to pass to the south of the castle and then through a new arch just before the station. It is noticeable how this arch was designed to blend with the architecture of the castle. After the station, the railway burrows underneath the walls in a short tunnel. The tunnel passes under Mount Pleasant and a look at one of the towers of the walls at this location shows it is considerably damaged. This was due to vibration from the trains passing through the tunnel. Also, in the nineteenth century an arch known as Porth y Sarn (Gate of the Causeway) was built close to the castle for the Llanrwst Road, which passes through Gyffin; this road passes under a railway bridge. Beyond this bridge is now a bowling green but at one time there was a timber yard here and before that, a mill. The causeway referred to is Sarn y Mynach (Monks' Causeway), which linked Aberconwy Abbey with Rhos Fynach Monastery in what is now Rhos-on-Sea. This route existed before the town of Conwy was built. It ceased to be used after the monks of Aberconwy Abbey were moved up the valley to Maenan.

The last arch to be built was the Berry Street Arch, which was cut in the early twentieth century. Until that time Berry Street was a cul-de-sac.

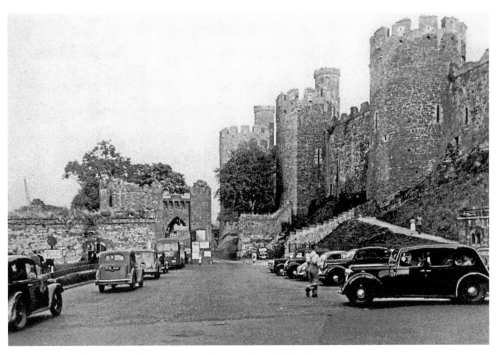

Above: Telford's nineteenth-century arch, now demolished.

Below: Bangor Road Arch, built by Telford in the nineteenth century.

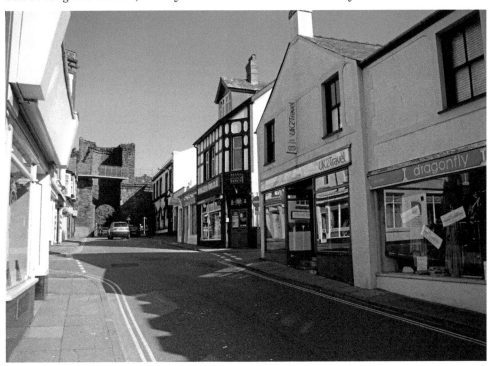

The tower in Mount Pleasant, damaged by the passage of trains though a tunnel.

Porth y Sarn, a nineteenth-century arch leading to Gyffin.

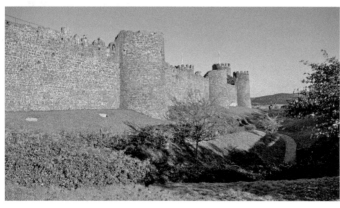

The southern section of the walls near the castle.

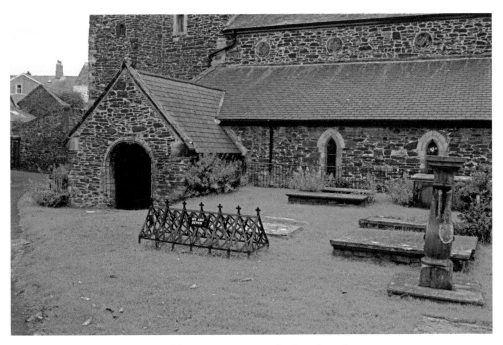

Commemoration of Wordsworth's poem in St Mary's churchyard.

55. We Are Seven

One of the most well-known memorials in St Mary's churchyard is 'We are Seven', which is connected with the poem written by William Wordsworth about a child who was trying to explain that she was one of seven siblings, and according to the poem 'two of us at Conway dwell'.

A grave (of a family of seven) near the south porch of the church, came to be associated with a conversation that inspired Wordsworth to write the poem. After this, because of the general popularity of Wordsworth, tourists came to the grave in large numbers and many of them chipped a piece off the gravestone to take home as a souvenir. In order to prevent the gravestone being completely destroyed, the famous architect Herbert North designed a metal cage that remains there to this day. Some historians call the accuracy of the story into question, while others claim the family lived in a house in Gyffin, a village to the south of Conwy, and that they are buried in Gyffin churchyard. Nevertheless, it is a story that still interests tourists.

56. John Williams (Archbishop)

John Williams was much involved in the life of Conwy at the time of the English Civil War. He was born in Conwy in the upper part of the town in 1582 and was baptised

at the font, which still stands in St Mary's Church. He graduated from Cambridge in 1601 and was ordained a few years later. A sermon he preached impressed James I, and after that his rise to high office was rapid and James appointed him the king's chaplain, then Dean of Westminster and then Bishop of Lincoln. Also, he was appointed to a political role as Lord Chancellor. After James I died, John Williams fell out of favour with the new king, Charles I, and later with Parliament. During this period, he was twice imprisoned in the Tower of London. On his release in 1642, he had gained favour with the king, who appointed him Archbishop of York. So Williams travelled to York, where the king was, but his stay there was short. The civil war had begun and the Parliamentarians drove him out of the city. He fled to his native Conwy to take command of the castle on behalf of the king. He knew that it was inevitable that Conwy, which supported the Royalist cause, would eventually be attacked, and he repaired the castle at his own expense. The wealthy people in the town were worried about their possessions in the event of Conwy being attacked, so Williams arranged for them to lock their valuable belongings in a secure place within the castle.

In December 1644, the king, whose cause was looking more fragile, called a parliament at Oxford and summoned Williams to attend, so he made the tortuous winter journey. When he returned to Conwy the following spring, Williams found that Sir John Owen, a Royalist, but also his enemy had been appointed by the king to govern Conwy, both town and castle. Owen took the castle by force and had his eyes on the treasures that Williams had stored there. Needless to say the people who owned them were worried. It appeared now that Williams had lost his cause at the same time as incurring the wrath of people who knew that John Owen would take their valuable belongings, which Williams promised would be safe. But there was a twist in the tale. Williams planned to attack the castle and negotiated with Mytton, commander of Parliamentary army, to give them his help on the condition that the people's belongings would be returned to them. So Williams changed sides. The Parliamentarians captured the castle in 1646 and Williams, by then aged sixty-four, took part in the battle and was slightly injured. It was thought that the Royalists would never forgive him, but possibly they did because they got their valuable possessions back!

Williams lived the remaining four years of his life in peace and prosperity at Gloddaeth Hall in Llanrhos, where he died. He was buried at Llandygai Church near Bangor, where there is a monument to his memory. So ended the life of this fascinating character, who was an academic, cleric, politician and soldier. Among his many legacies, mainly to charitable and educational causes, he left a substantial sum to St John's College, Cambridge, for the building of a library. Interestingly, St John's has had special connections with Wales ever since. All that remains of his memory in Conwy is the wall of what was Parlwr Mawr, the house where he lived in Chapel Street, which is commemorated by a suitable plaque. The nearby York Place also brings memories of him.

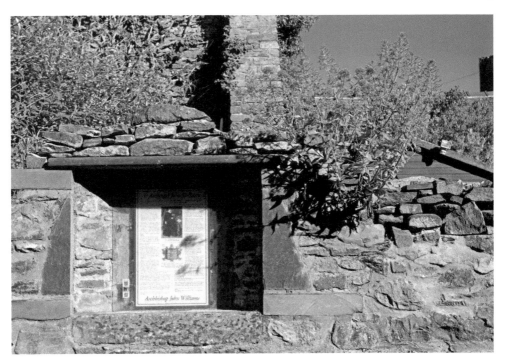

Remains of Parlwr Mawr where Archbishop John Williams lived.

57. Margaret Williams (and Robert Jones)

Margaret Williams was truly one of the great characters of Conwy, a Jackdaw born within the town walls. Many people came to know this lady of great ability when they visited the Smallest House. In her early life, she trained as a journalist and worked for the *North Wales Weekly News*, whose premises were then located on the Quay. She also worked on the *Chester Chronicle,* then she moved to Liverpool to work as a public relations officer at Owen Owen's store. She also worked as a freelance journalist and contributed many articles to the *Daily Post*. She had skills in fashion and design that took her to Paris. She wrote articles for fashion magazines and travelled widely, even as far as Australia.

Margaret's great-grandfather was Robert Jones, whose ancestors built houses on the Quay. Robert's mother seems to have been quite a character. He seems to have inherited much of his character from his mother, who was the first person to walk across Telford's 1826 suspension bridge before it was officially opened, despite warnings that she should not do so. An interesting story about Robert is when he went to Tal-y-Cafn, about 4 miles up the river to collect a Welsh dresser for Conwy solicitor James Porter. As country roads in those days were little more than footpaths, people did not believe that Robert would ever be able to get this large piece of furniture to

Conwy. However, Robert had his plan. He would not use the roads, but he tied the dresser to a boat and rowed it downriver to Conwy. He was certainly a man who would not let anything defeat him. He owned a number of houses on the Quay, which were let to tenants but in 1900 the council told him that he would have to find other accommodation for his tenants as these houses were too small, particularly the very small one. At the suggestion of the editor of the local newspaper, Robert turned the house into a tourist attraction, as tourists were now coming to Conwy in increasing numbers. Robert's two sons were not interested in the project, so he bequeathed the house to his granddaughter Elizabeth. Her husband Robert Williams was descended from a family who once lived in Plas Mawr. Elizabeth and Robert's daughter, Margaret, subsequently inherited the house in 1987.

Now to return to Margaret's story, she certainly seems to have inherited the entrepreneurial skills of her great-grandfather. She progressed from writing freelance newspaper and magazine articles to writing books, which were very popular. Many of her books are about the Smallest House and the people associated with it, and her books about Conwy included a book of ghost stories. She could also turn to public speaking and as the Smallest House became better known, she gave talks to the passengers on cruise liners visiting North Wales, among them the *Queen Elizabeth II*. Margaret also had musical skills and could play the piano. As tourism increased in the mid-twentieth century, Margaret, like her great-grandfather before her, saw the potential and when the local council suggested that for one week the shopkeepers in

Margaret Williams, whose memory will always be associated with the Smallest House.

Conwy should dress up in Welsh costume, Margaret took up the idea with enthusiasm, but for her it was not just a week because she continued the tradition. It may have been Robert who started the Smallest House as a tourist attraction, but it was Margaret who made it what it is today. She died in 2015, but the ownership of the house remains in the family. *(See* 48. Smallest House)

58. Albert Wood

Albert Wood's family acquired great wealth from their company Henry Wood & Co. Originally, the company, which manufactured anchors and chains, was in Stourbridge in the West Midlands but by the mid-nineteenth century had set up at Saltney near Chester and made anchors for many famous ships. They were associated with Hingley & Son, another midlands company who eventually took them over. Hingley's manufactured the anchor and chains for the *Titanic* and the *Lusitania*. In 1877, Albert Wood built Bodlondeb and commuted to Chester to go to his business at Saltney. He used to get the train to Chester from Llandudno Junction, rather than Conwy, probably because after Llandudno Junction station was built, fewer trains stopped at Conwy. He found it somewhat inconvenient to have to travel in his horse-drawn carriage up Town Ditch Road, which was then no more than a track, and enter Conwy through the Bangor Road Arch, so in the early twentieth century he built a new arch into Berry Street so he could leave and enter the town more quickly. Until then, Berry Street had been a cul-de-sac. He was a person of some significance in the town, and among his other local positions he was a magistrate. He was mayor of Conwy on eleven occasions. He paid for the statue of Llywelyn the Great in Lancaster Square. While he lived at Bodlondeb, he entertained many famous people, including Prime Minister David Lloyd George, and the famous composer Sir Edward Elgar. It is thought that Queen Victoria thought of visiting him but she considered the house too small to accommodate all her travelling staff.

59. X-roads

A crossroads (X-roads) always requires anyone approaching it to make a decision on which way to go. This is usually thought of in terms of a road journey, but it can equally apply to a crossroads in the life of a person, a building, a town or even a country. The town of Conwy has faced many 'X-roads' in the centuries of its existence.

Decisions began with the Cistercian monks deciding where to build their abbey, then the decision of Edward I choosing where to build a castle, town and walls and where to move the monks. Decisions had to be made by the indigenous Welsh people as to how to react to being barred from entering the town, and consequently some battles followed. In Tudor times, wealthy families had to decide where to build their homes, then a century later the people of Conwy had to decide which side to support in the civil war. In later years, decisions involved how to find the best way of crossing the river, and subsequently how to decide what to do about increasing road traffic. Such decisions continued to be made with some controversy right up to the last decade of the twentieth century. The decisions that were made over the centuries have made Conwy the town it is today. The future is always uncertain, and residents and visitors look with interest about how future decisions will affect the town.